LINCOLN

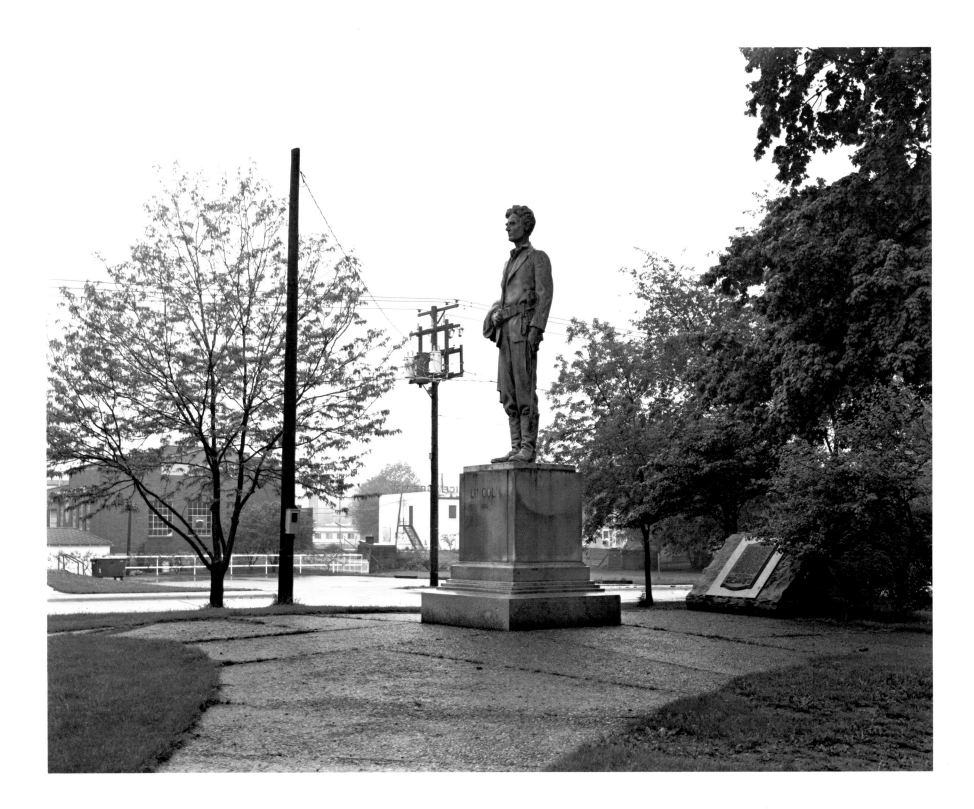

Dixon, Illinois, 1983

LINCOLN

George Tice

Rutgers University Press
New Brunswick, New Jersey

BOOKS BY GEORGE TICE
Fields of Peace (with Millen Brand)
Goodbye, River, Goodbye (with George Mendoza)
Paterson
Seacoast Maine (with Martin Dibner)
George A. Tice/Photographs/1953-1973
Urban Landscapes
Artie Van Blarcum
Urban Romantic

Library of Congress Cataloging in Publication Data

Tice, George A.
 Lincoln.

 1. Lincoln, Abraham, 1809–1865—Monuments, etc.—
Pictorial works. 2. Lincoln, Abraham, 1809–1865—
Iconography. I. Title.
E457.6.T54 1984 973.7′092′4 83-23002
ISBN 0-8135-1045-7

To Abraham Lincoln
On the occasion of the 175th anniversary of his birth

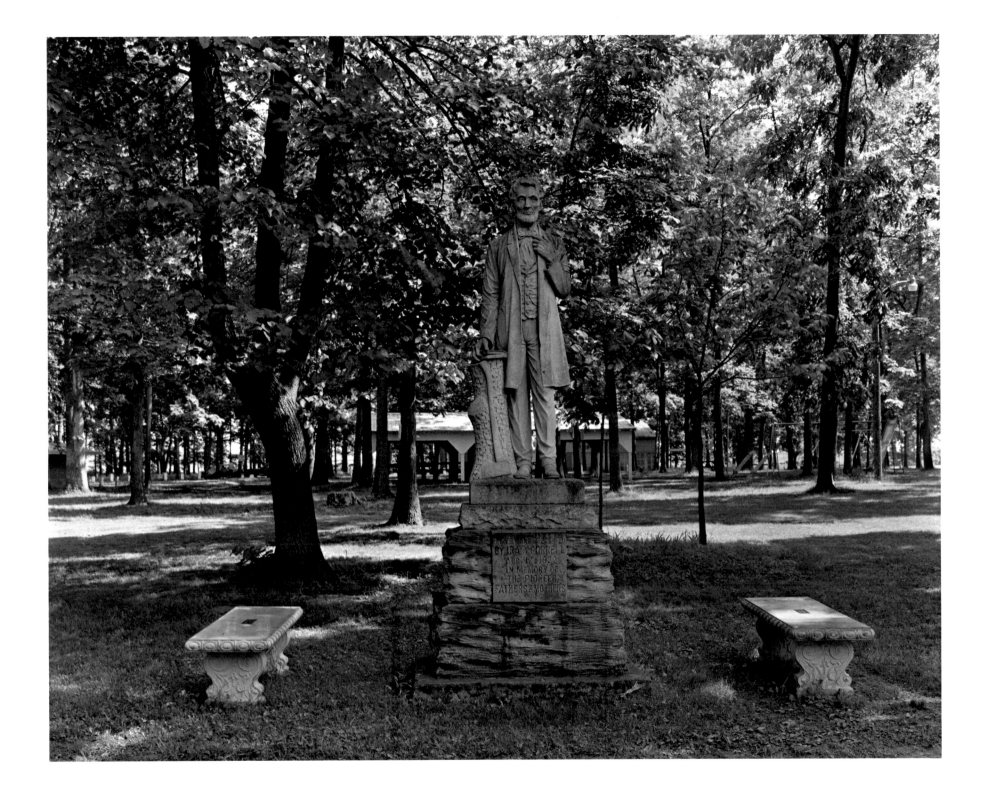

Odon, Indiana, 1982

It was Carl Sandburg who led me to Lincoln. I wondered why he had labored for twenty-five years on his six books about Lincoln. When I saw that these volumes had been compiled into one big book, *Abraham Lincoln,* I bought one. It took the entire summer for me to read through the six hundred and forty pages and by then I was hooked. Sandburg cautions, "The son of a gun grows on you."

I now have a Lincoln library of over one hundred and fifty books. I'm told there are ten thousand others and that there are more on only one other figure—Christ. Studying the life and character of Abraham Lincoln, I came to see him as the ideal man, a model for all men, especially Americans.

I began collecting nearly everything I came across on Lincoln: notes he wrote, documents he signed, campaign pins, mourning badges, medals, bookends, sculpture, portraits of all kinds. I even have a brick from his law office in Springfield, Illinois.

That I would do a Lincoln book didn't occur to me until the night I came upon the Lincoln Motel and Abe's Disco. There he was right in the heart of Newark, all lit up in neon and flashing lights. My mission was clear; I would travel America looking for Lincoln.

Illinois is the "Land of Lincoln." In Dixon, hometown of Ronald Reagan, I photographed a young Lincoln, a twenty-three-year-old Captain of the Black Hawk War. I thought a young Reagan must have visited this very site. I wondered what inspiration this statue might have had in shaping a future President. I didn't consider it long since it was raining hard and I drove on to Freeport, where Lincoln debated against Stephen Douglas.

I found Lincoln waiting, oblivious to the rain. I was tempted to offer an umbrella, but I didn't. He was too lost in thought to disturb. I got his picture and moved on to Iowa. Lincoln was a journey.

At the Lincoln Auto Center in Lincolnwood, Illinois, I was searching

for a place to set my tripod down when I found a penny. I pocketed the penny and took the picture on the spot. Lincoln was everywhere.

Some of my photographs were researched in phone books. In Indianapolis, under Lincoln, I found the Lincoln Inn. When I got there, I saw *Lincoln Inn* was painted out and changed to *Ruthi's Go-Go*. Inside were mostly biker types. I stayed and bought a drink for a pretty dancer who sat at my table. She told me she was a truck driver and only danced part time. She said they changed the name about six months ago when Ruthi bought the place.

In my home state, New Jersey, we used to have a town named Lincoln, now it's called Middlesex. Most but not all localities named Lincoln are for our sixteenth President. I almost made a mistake in Lincolnton, North Carolina. I saw a Lincoln Pawn Shop I wanted to photograph and thought, "how fitting for a Southern city to honor itself by honoring him." After driving around, I began to think the town looked older than Lincoln himself. At City Hall I asked the clerk, "Is this town named for Abraham Lincoln?" I

learned Lincolnton was established in 1785 and named for Benjamin Lincoln, a hero of the Revolutionary War.

In Asheville, North Carolina, I asked a woman who grew up there, "Is Abraham Lincoln a national hero?" She said, "Yes, of course he is. We studied him in school." I asked if she got a holiday when his birthday came around. "No," she said, "but we did for George Washington." I asked if the stores in town run Lincoln birthday sales. She said, no, she thought not. I said, "If you don't get the day off and it's not a good time to go shopping, do you still believe he's a national hero. I mean, he did preserve the Union?"

I had forgotten which way I was trying to convince her, so I tried another approach. I said, "Many of these Lincoln statues that dot the country were commissioned by individuals. Suppose I was rich and generous and I wanted to give the people of Asheville a magnificent gift, a great work of art, a work that Lincoln Center in New York would be proud of. I'm going to give them a full-sized replica of Saint-Gaudens's masterpiece which stands in Lincoln Park

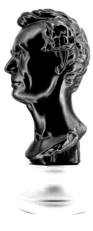

in Chicago." She knew what I was getting at. I said, "All the city has to provide is a public area. Would they accept my gift?" She said, "There would be opposition to it and probably not." I asked if there would ever come a time when this could happen. She thought it over and said it could be done in about twenty-five years. That would be just in time for his two-hundredth birthday.

At the Lincoln School in Omaha, I spoke with a teacher during recess. I told her their statue portrayed a man five foot four. Lincoln was six foot four. She said, "He may be a little short, but we love him anyway."

There is a movement underway in Boston to remove their statue depicting Lincoln freeing a kneeling slave from his bondage. It has stood in Park Square since 1877. Now some find the work to be offensive and want it banished.

In Wilkensburg, Pennsylvania, somebody stole Lincoln. I was so disappointed, I took the picture anyhow.

In Bennington, Vermont, I heard how they acquired their Lincoln statue, popularly known as *Faith, Hope and Charity*. It was to be purchased by John D. Rockefeller for Rockefeller Center in New York. But he wanted some changes made first, principally a fig leaf for the young boy's genitals. The sculptor refused and died with the sculpture in his possession. His heirs donated it to the Bennington Museum, where it stands at the entrance.

The true title of the Bennington work is the *Spirit of America*, by Clyde Hunt. It was he who said, "The inspiration and guide of every American artist should be the interpretation of American life and the American spirit."

While looking for Lincoln, I caught a glimpse of America. My journey took me to fifteen states plus the District of Columbia. There are thirty-five others—but that's another book.

October 4, 1983 GEORGE A. TICE

Newark, New Jersey, 1981

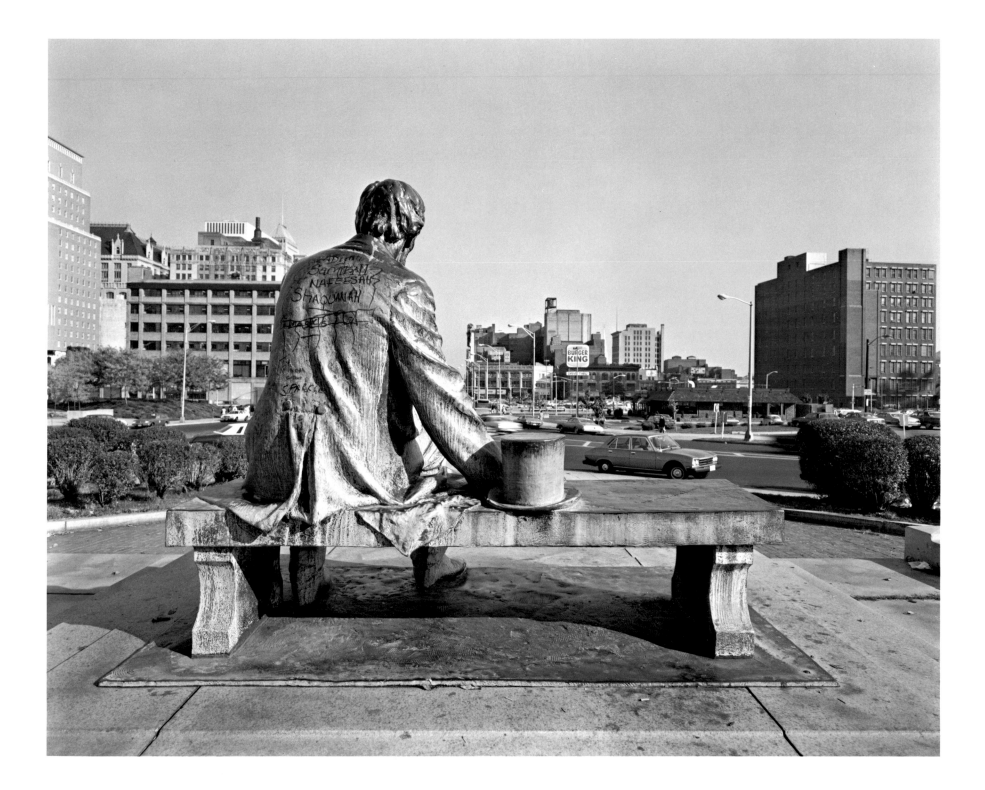

Jersey City, New Jersey, 1982

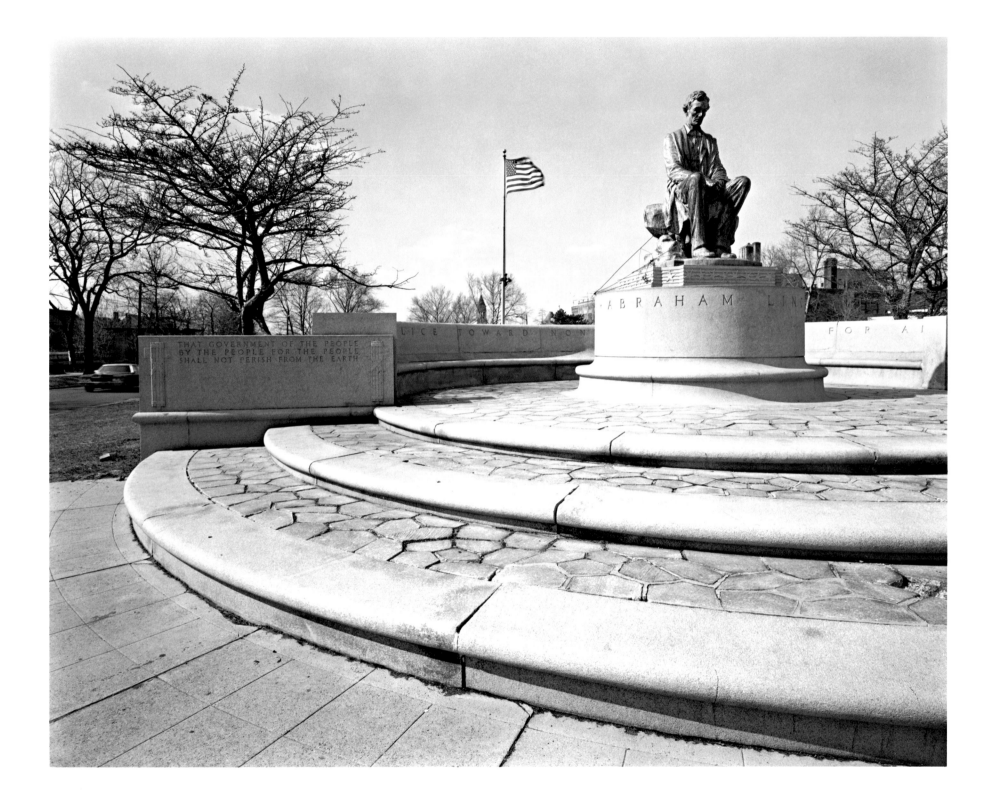

Lincoln, Nebraska, 1983

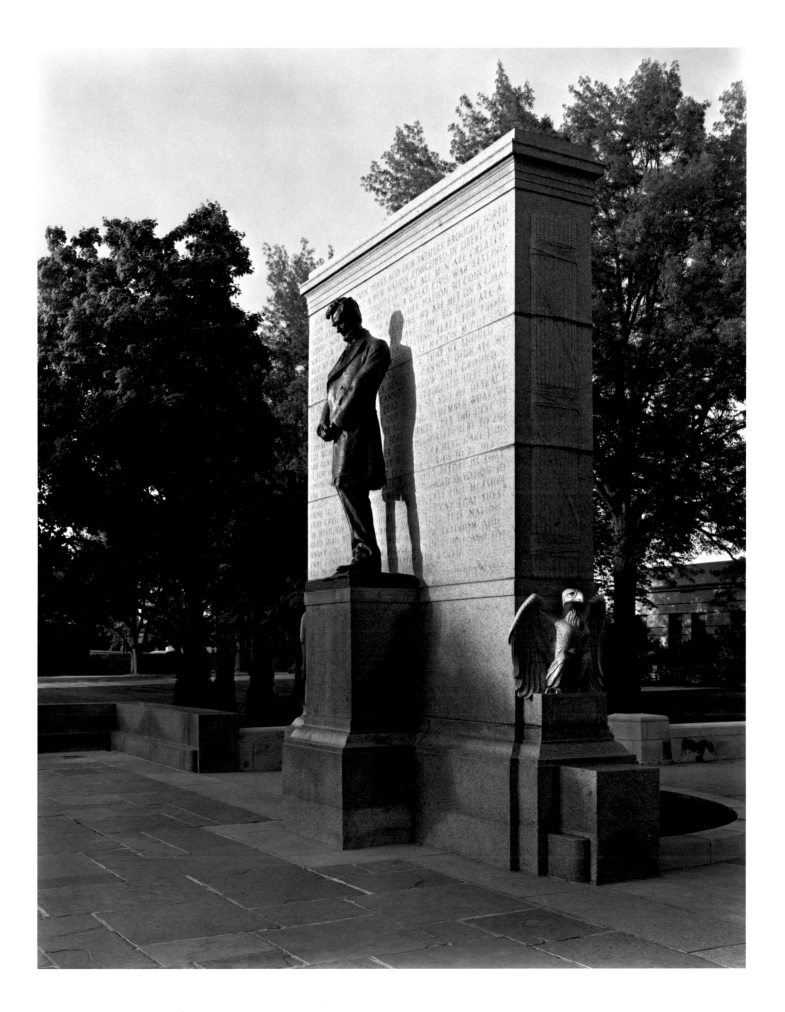

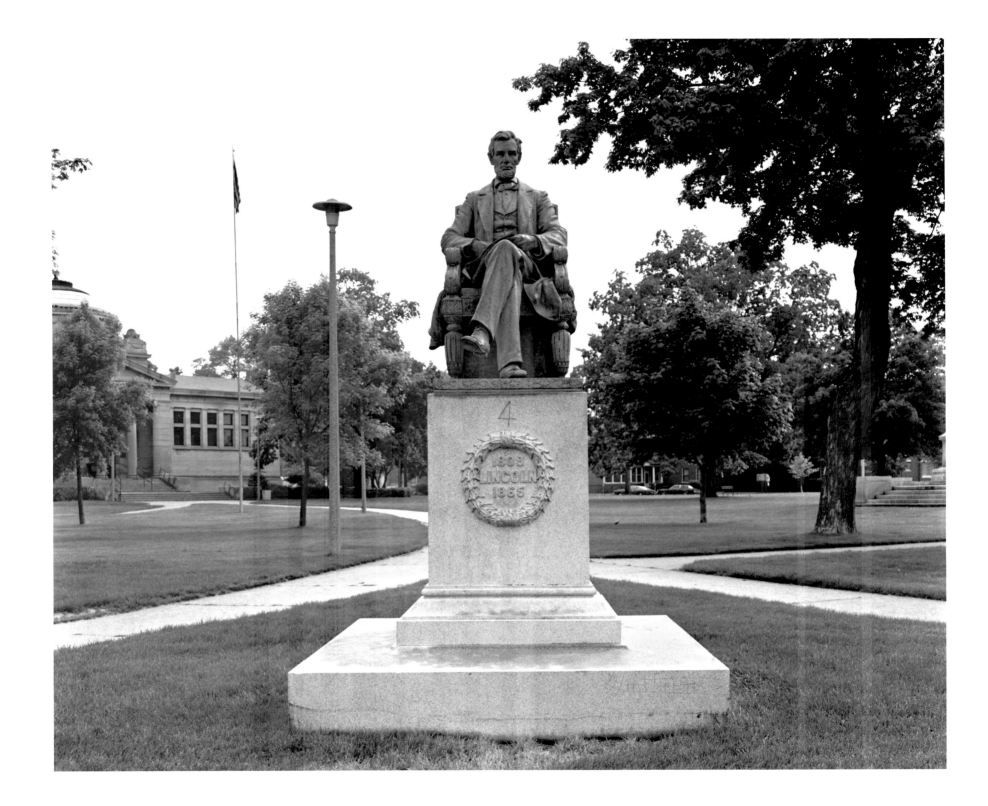

Kenosha, Wisconsin, 1982

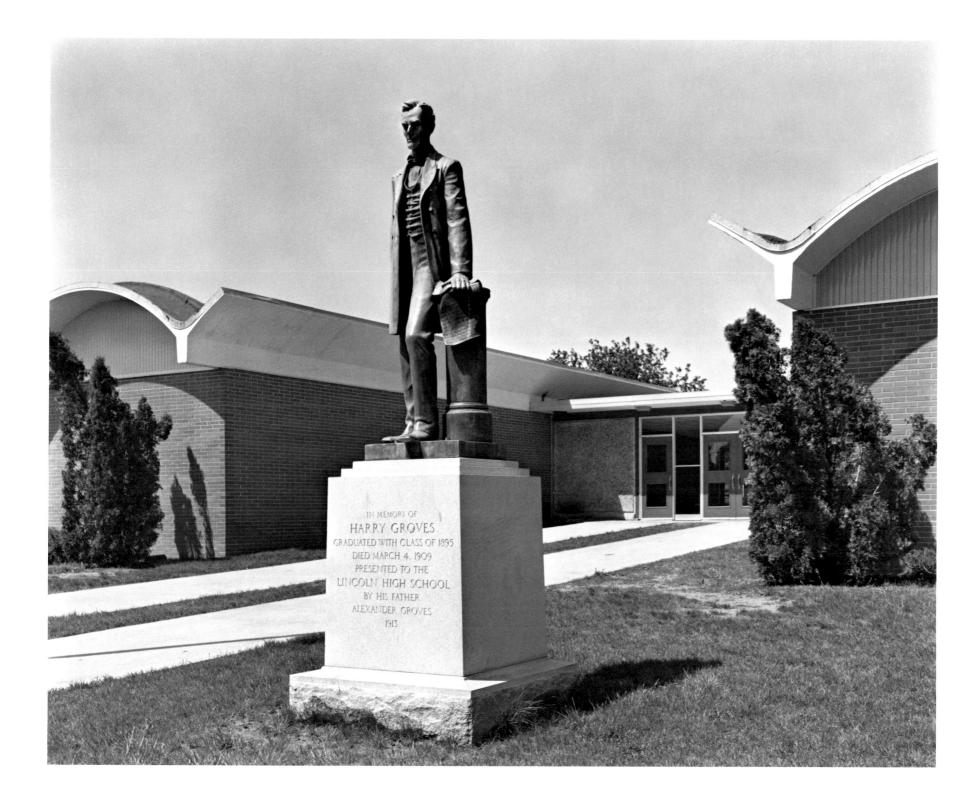

Webster City, Iowa, 1983

Cleveland, Ohio, 1983

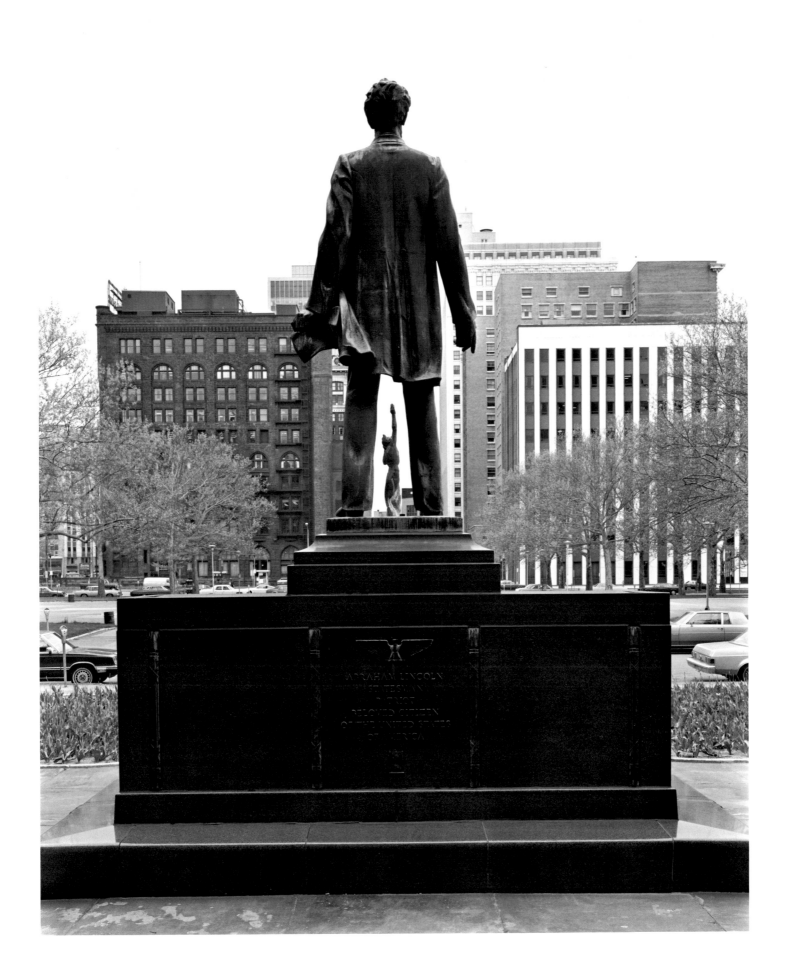

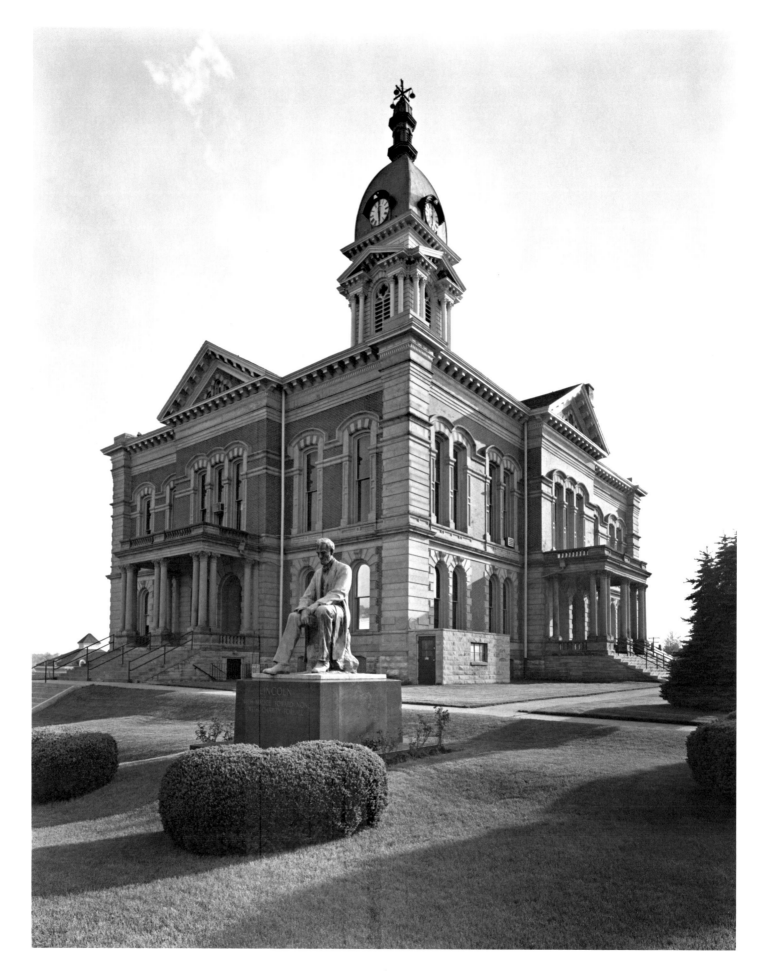

Wabash, Indiana, 1983

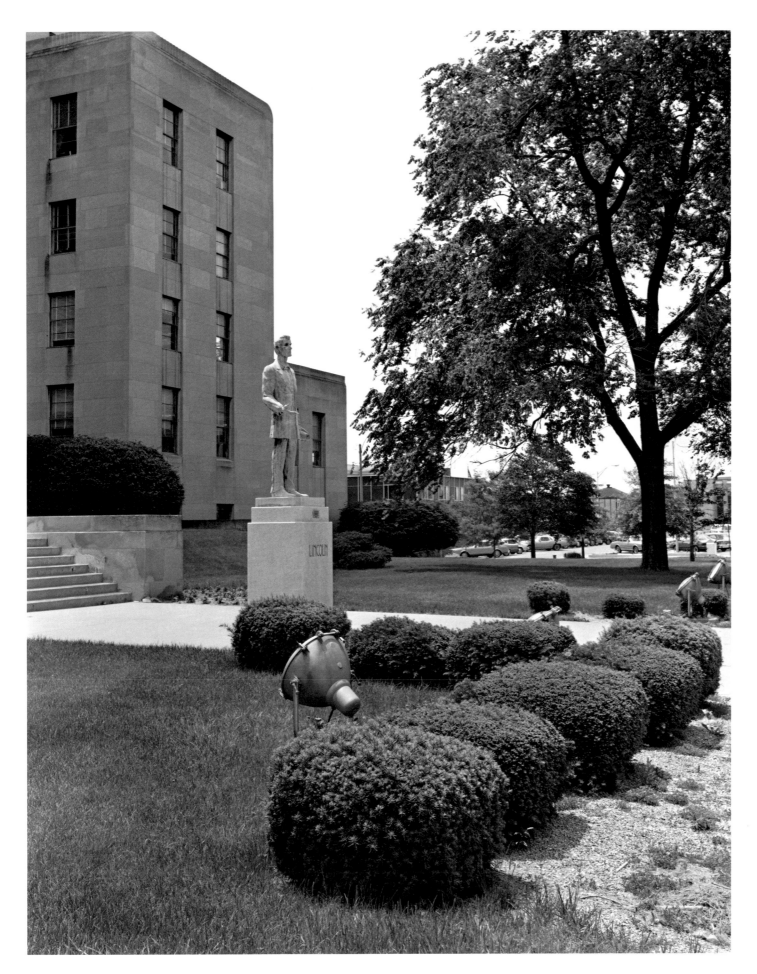

Decatur, Illinois, 1982

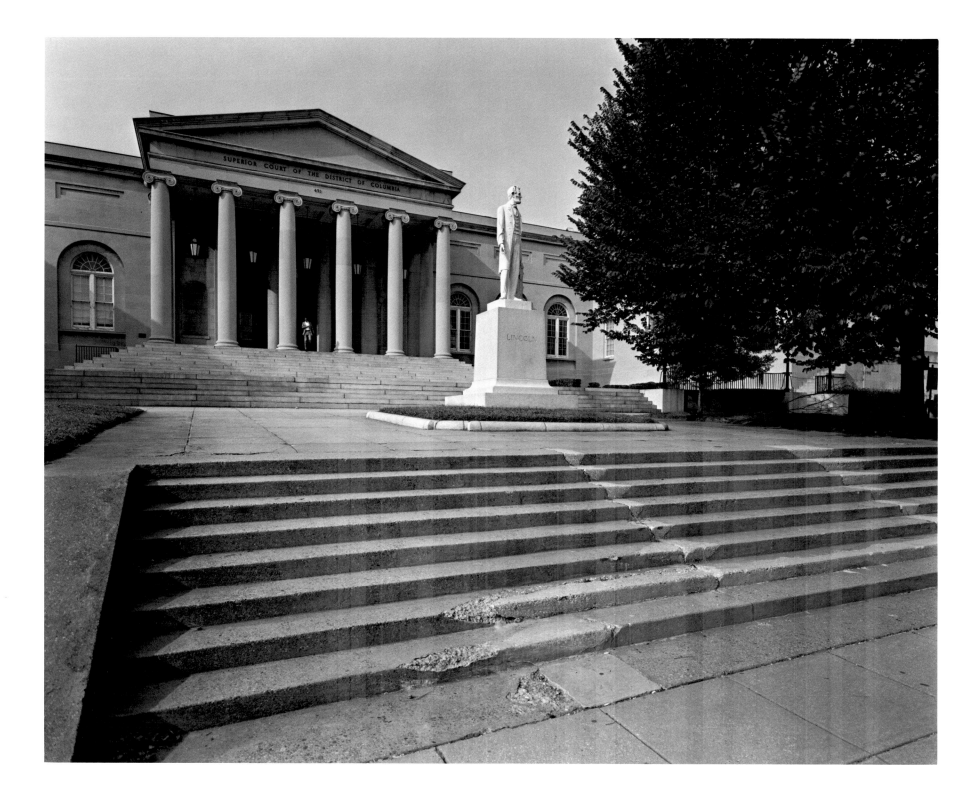

Washington, District of Columbia, 1983

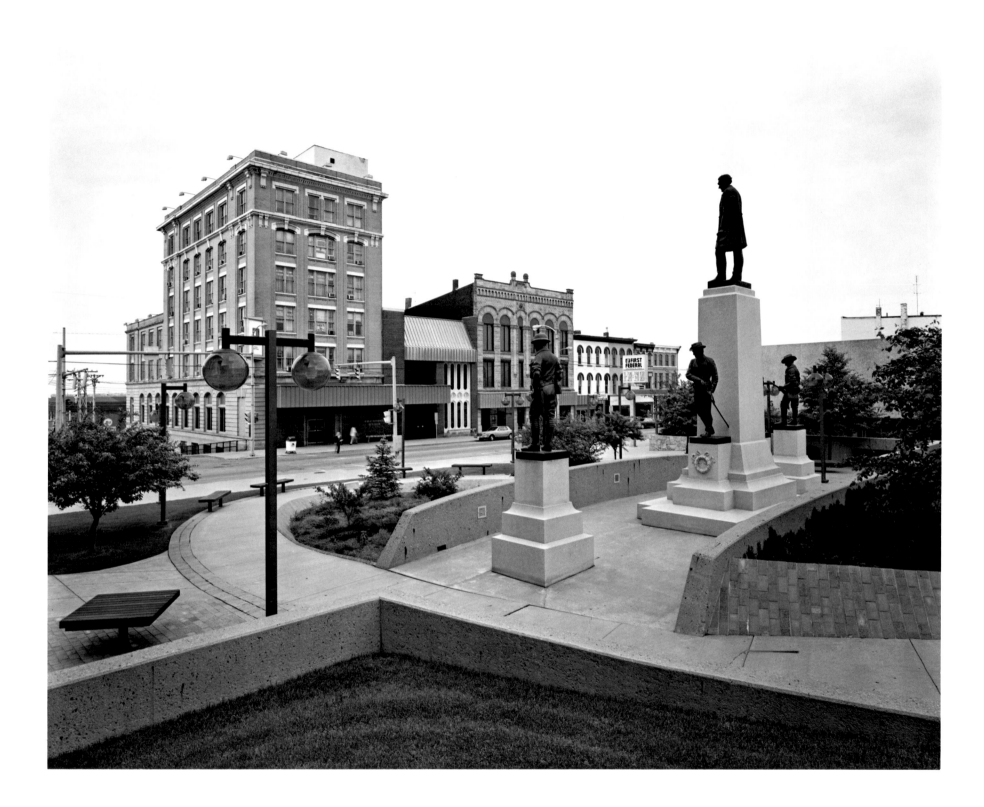

Alliance, Ohio, 1982

Boston, Massachusetts, 1982

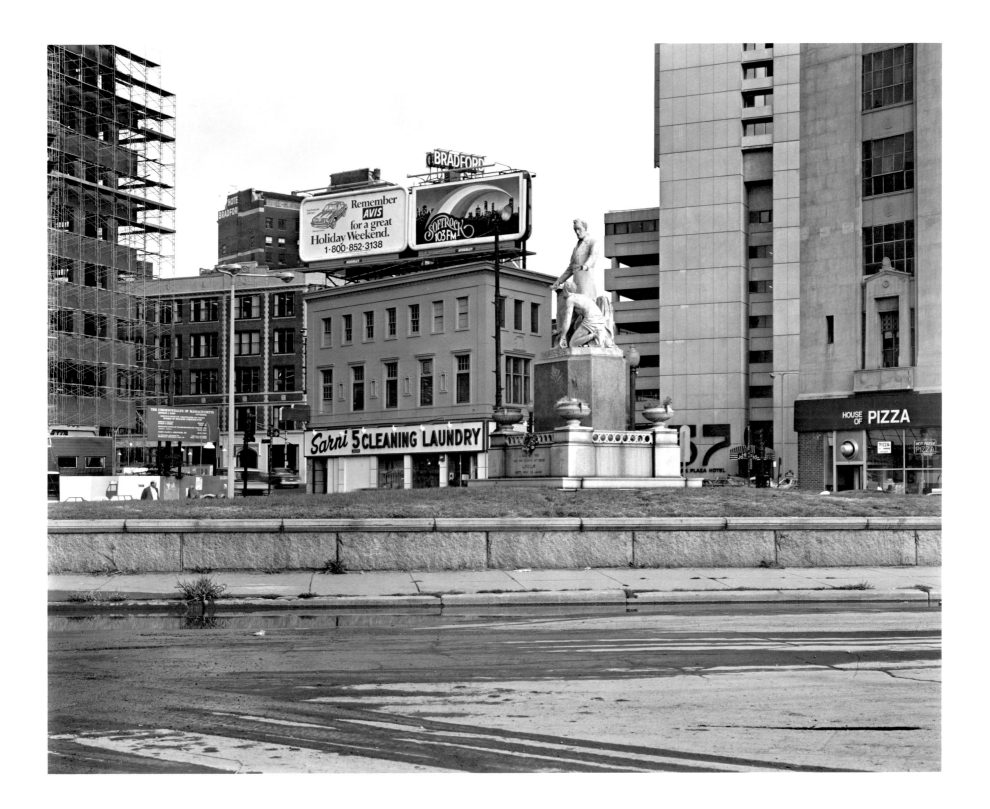

Washington, District of Columbia, 1982

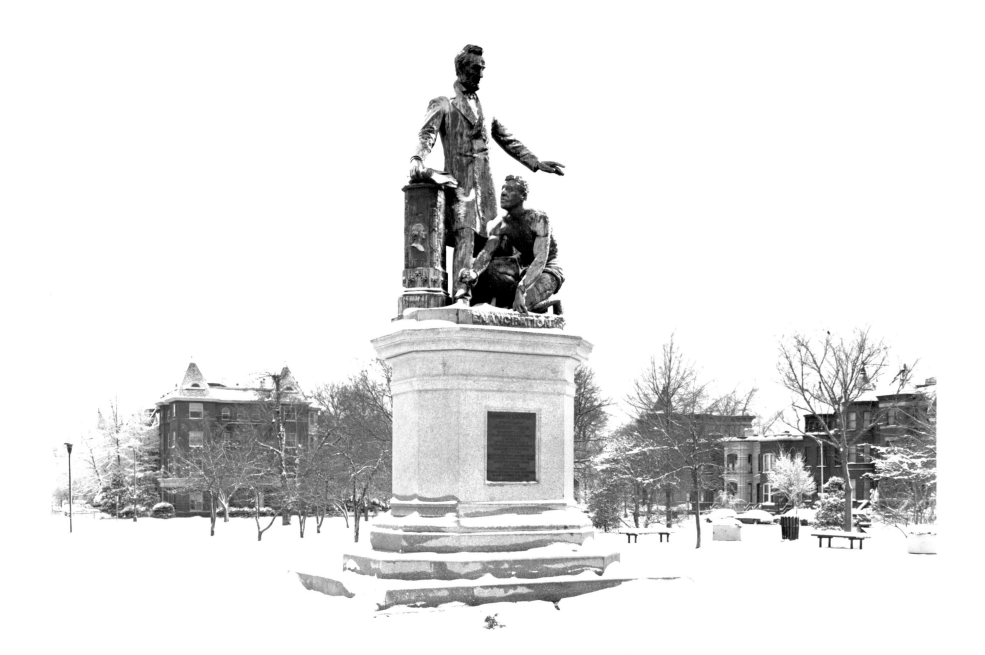

Urbana, Illinois, 1982

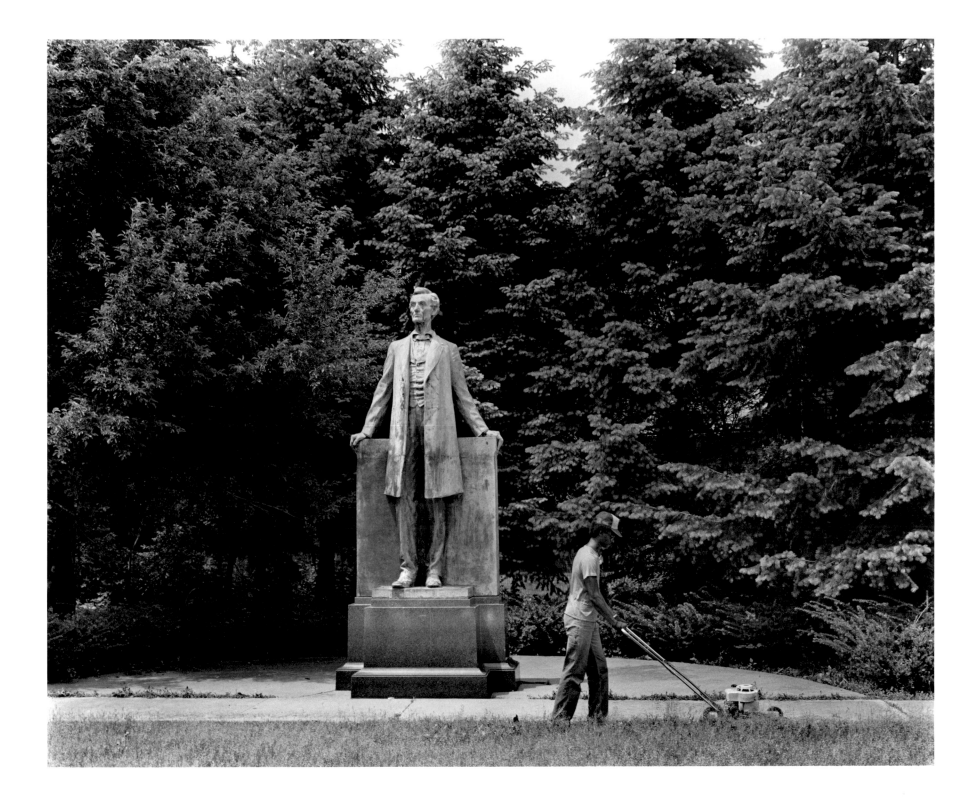

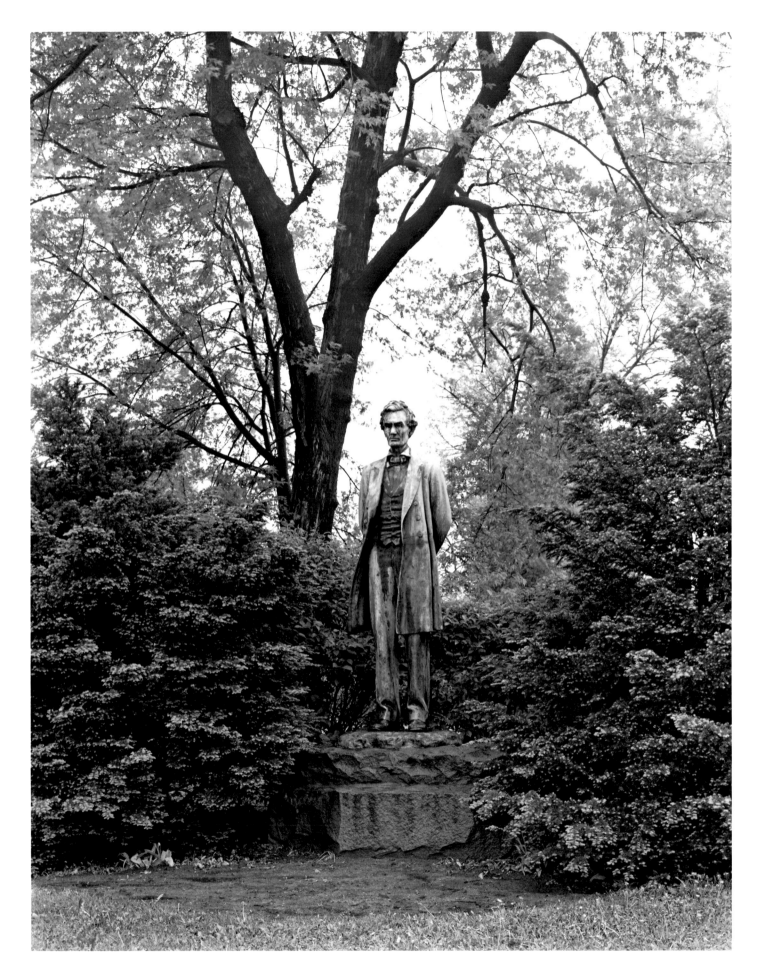

Freeport, Illinois, 1983

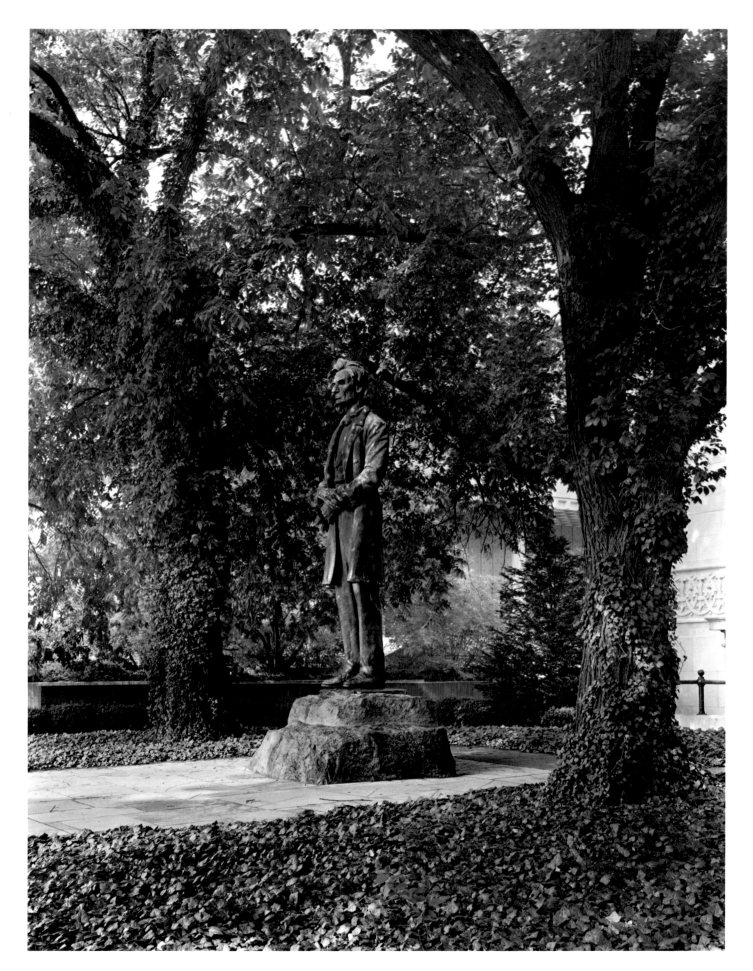

Louisville, Kentucky, 1982

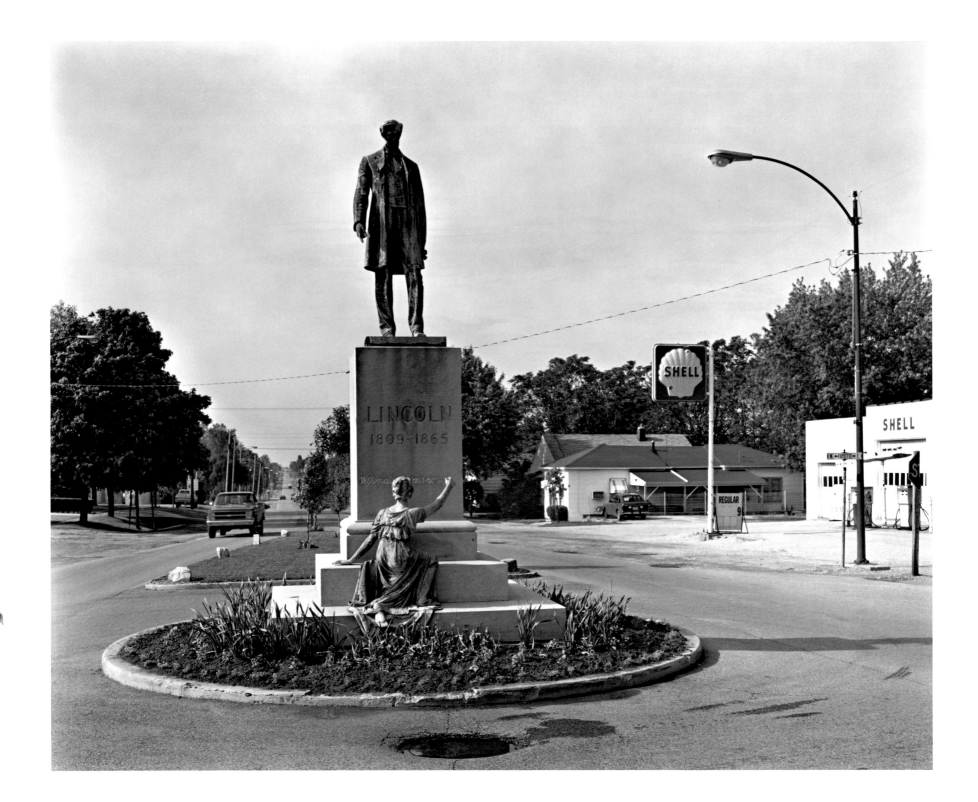

Bunker Hill, Illinois, 1983

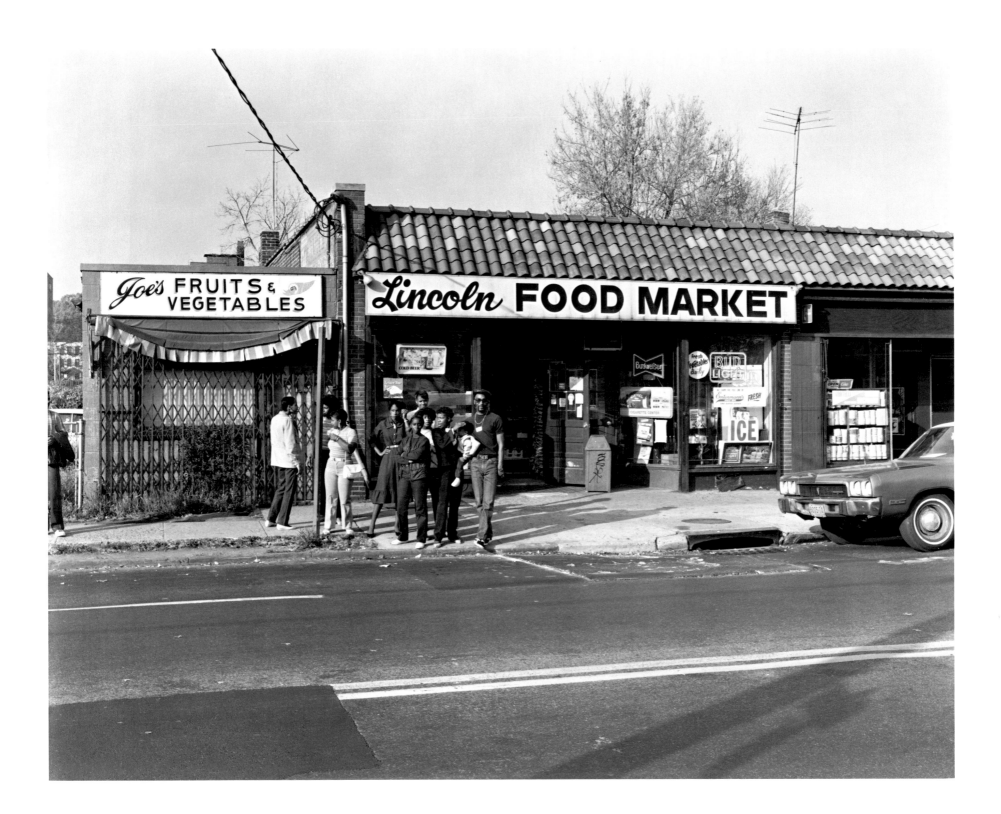

New Rochelle, New York, 1982

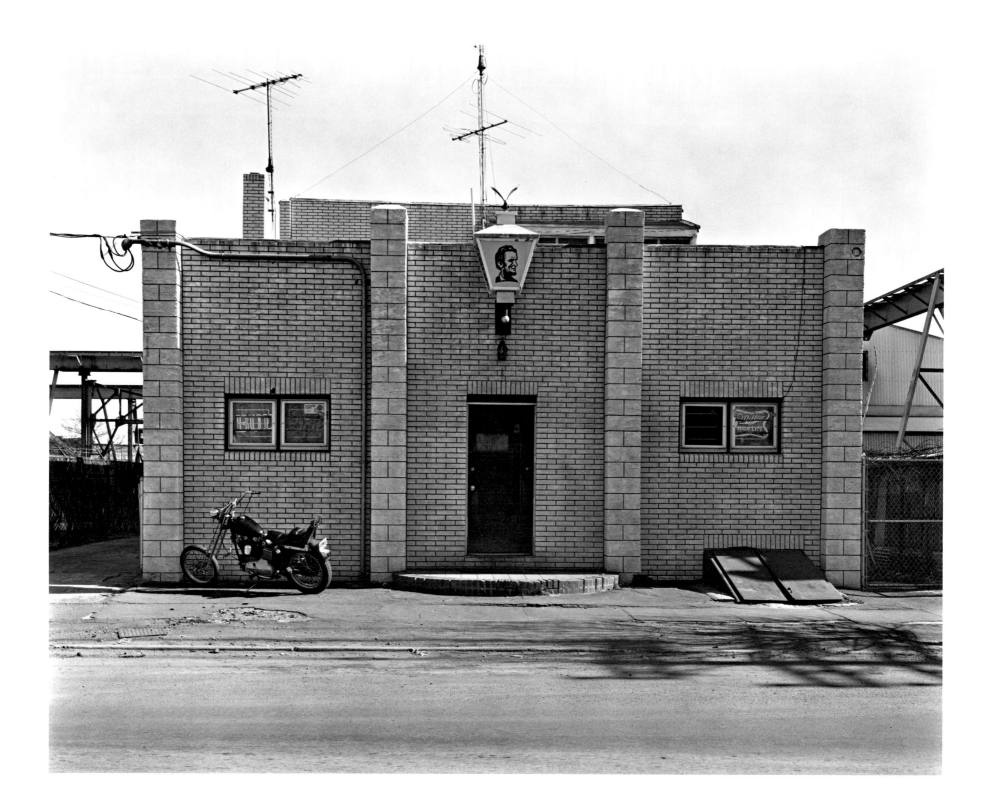

Middlesex, New Jersey, 1982

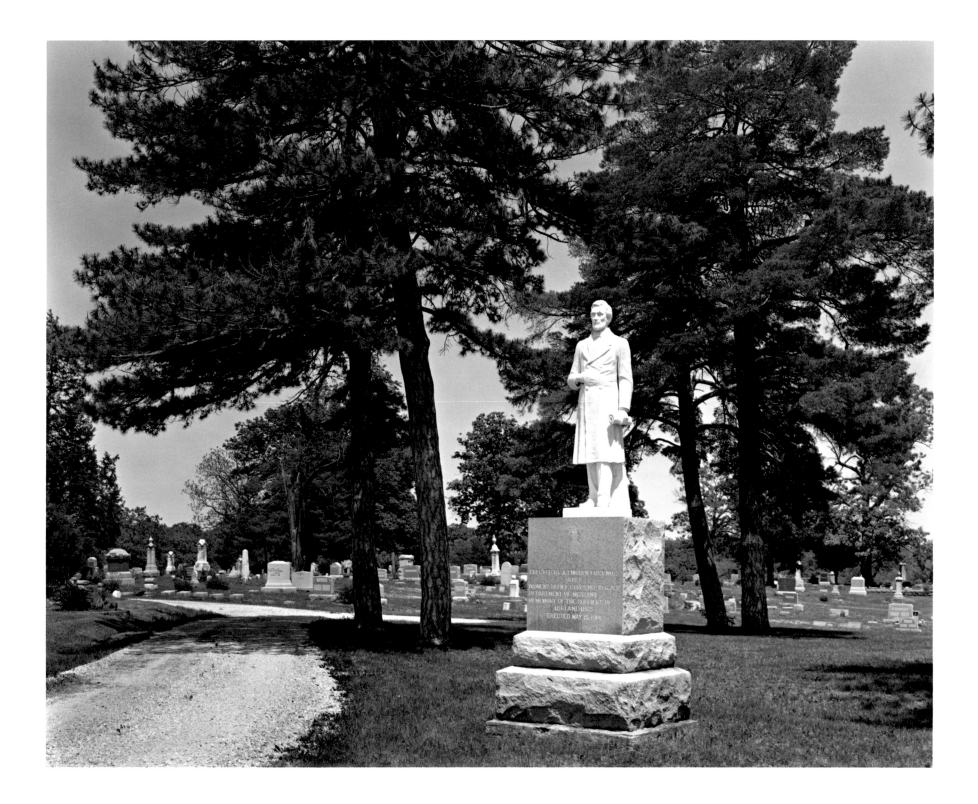

Moberly, Missouri, 1983

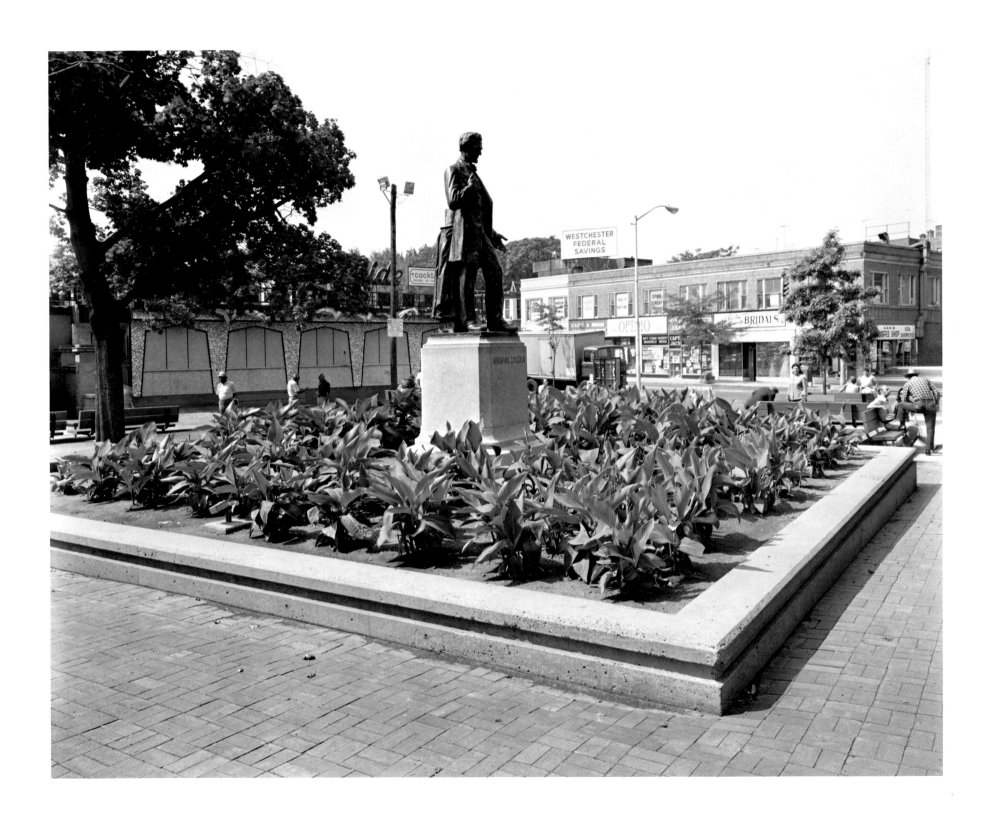

Yonkers, New York, 1982

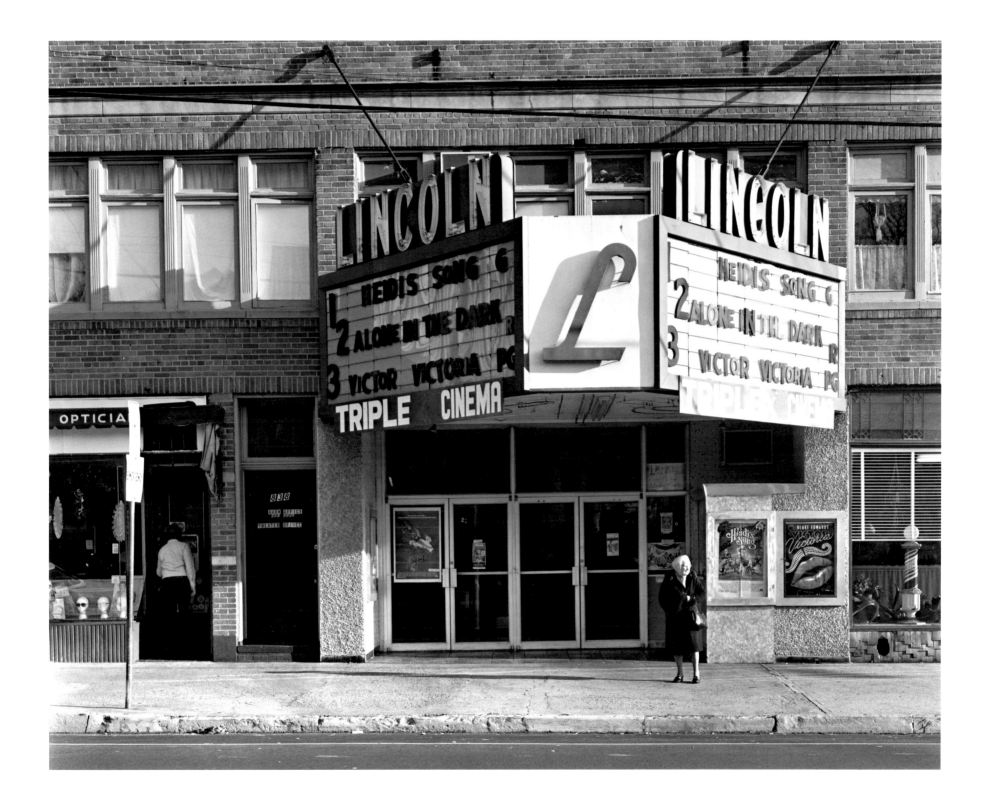

North Arlington, New Jersey, 1982

Linden, New Jersey, 1983

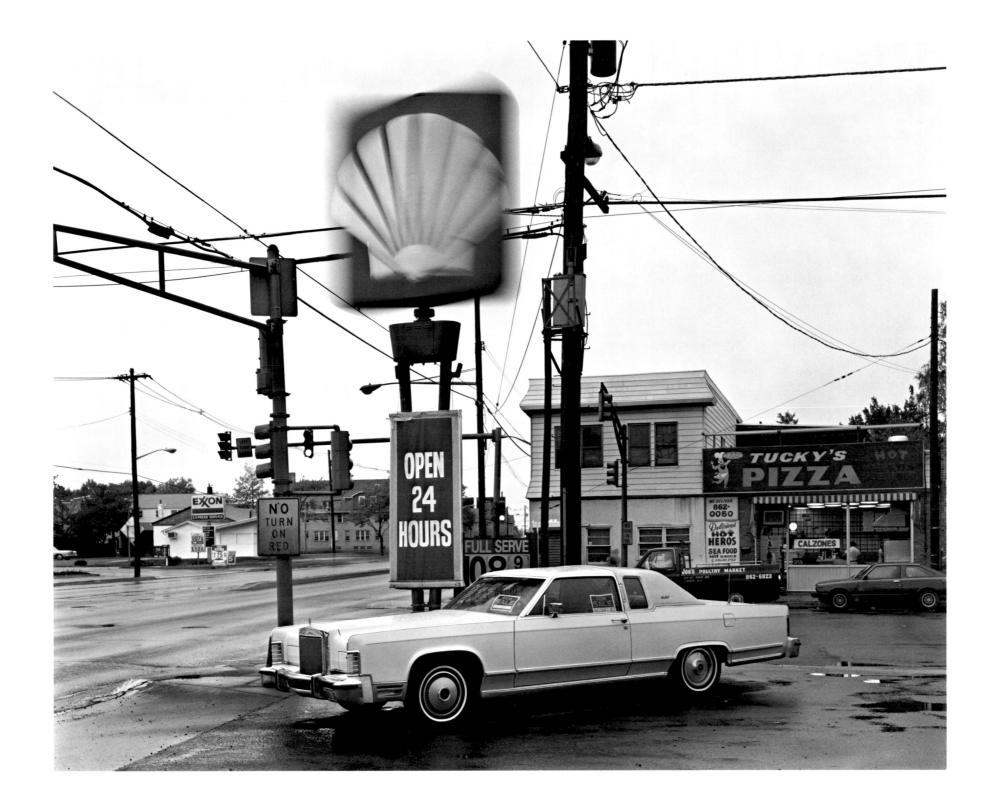

Racine, Wisconsin, 1982

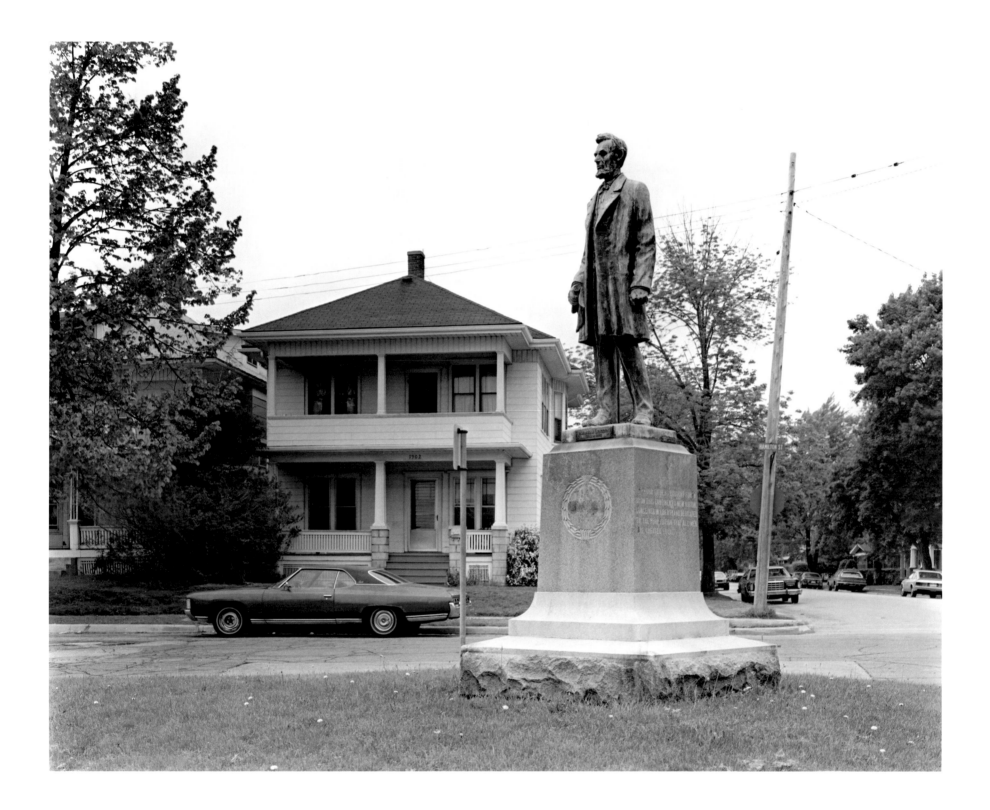

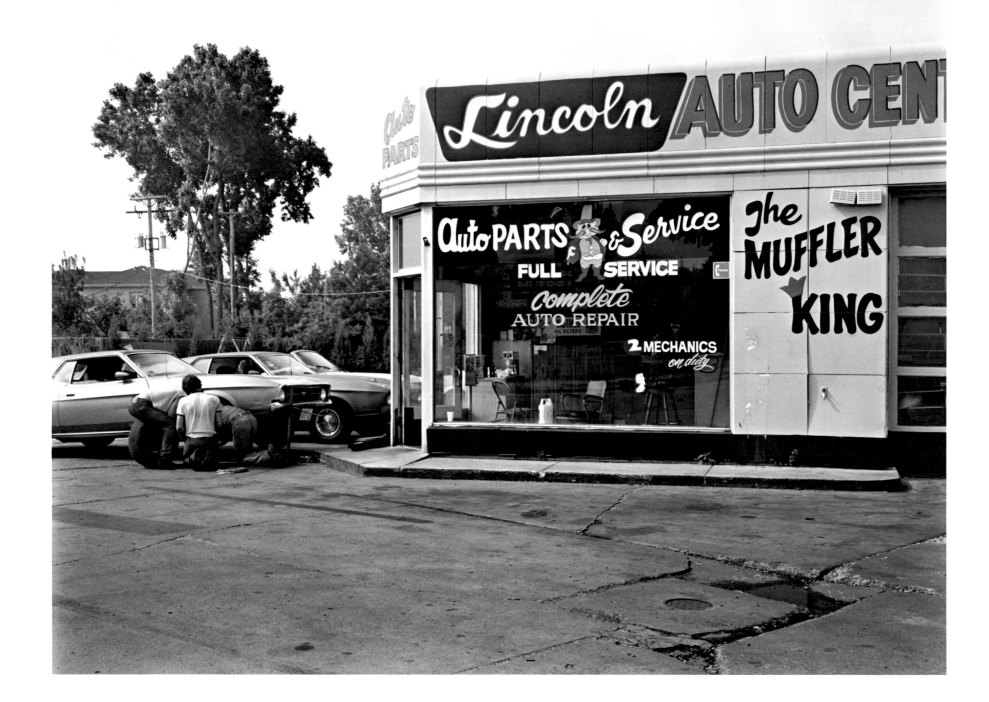

Lincolnwood, Illinois, 1982

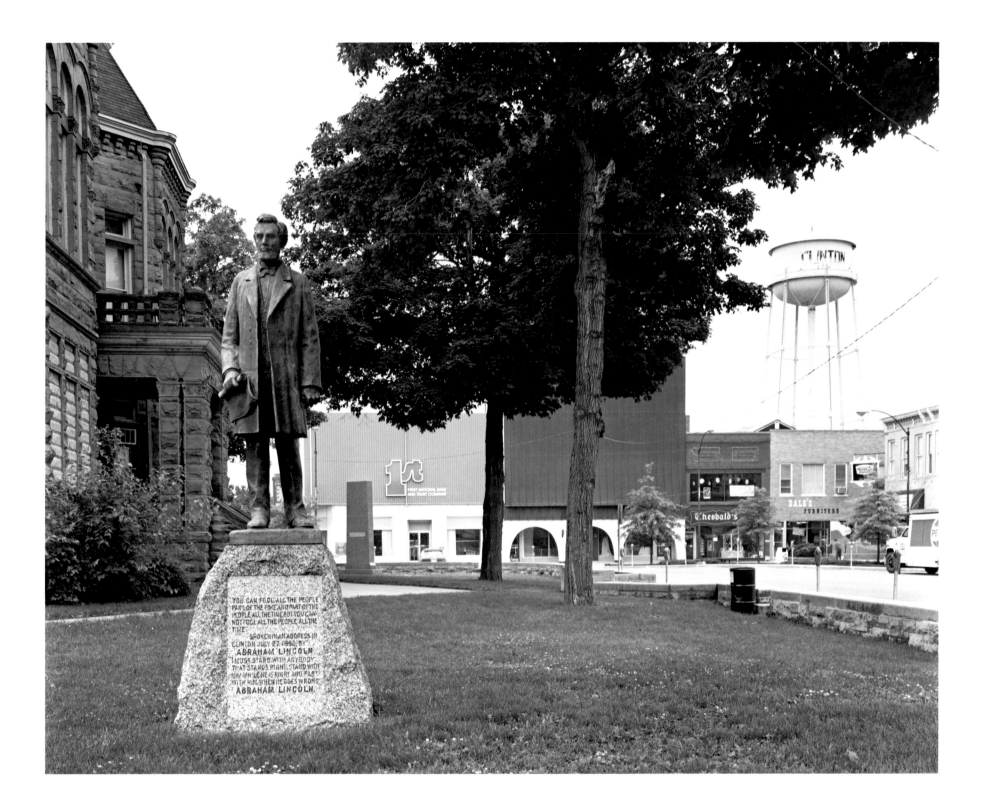

Clinton, Illinois, 1982

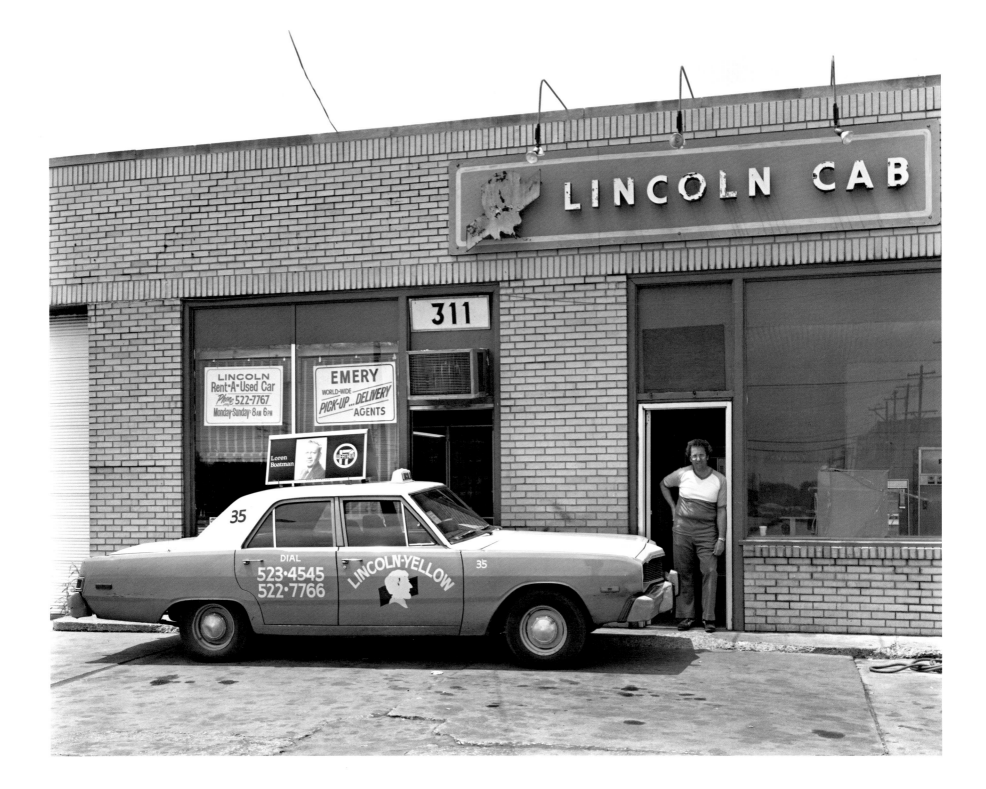

Springfield, Illinois, 1983

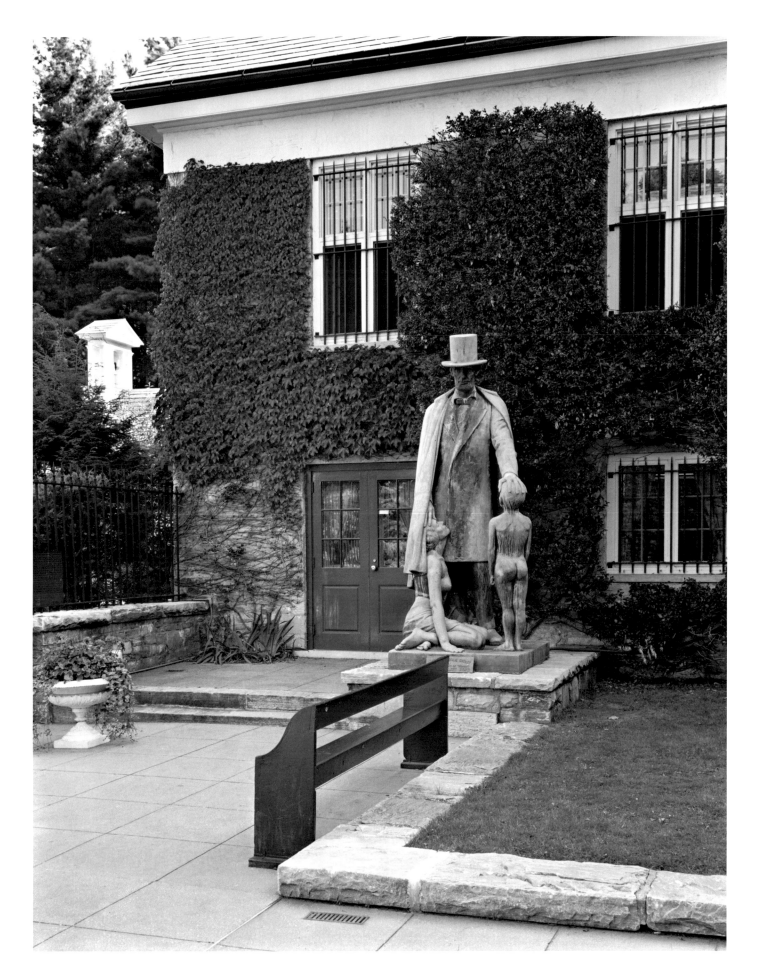

Bennington, Vermont, 1982

Racine, Wisconsin, 1982

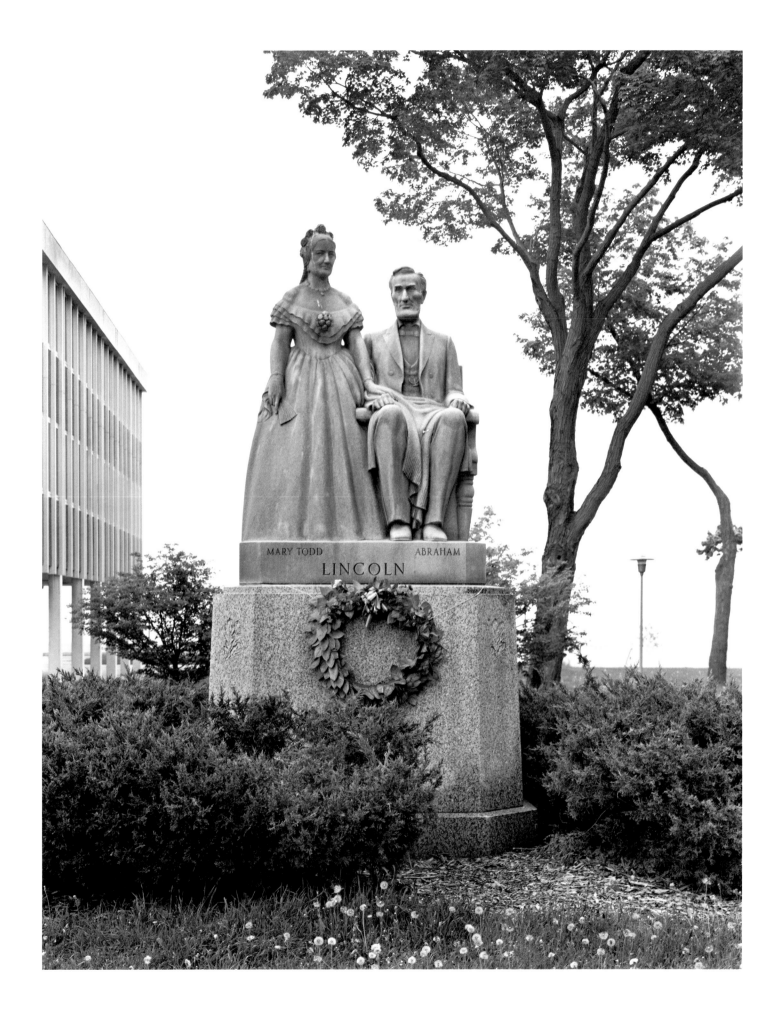

Chicago, Illinois, 1982

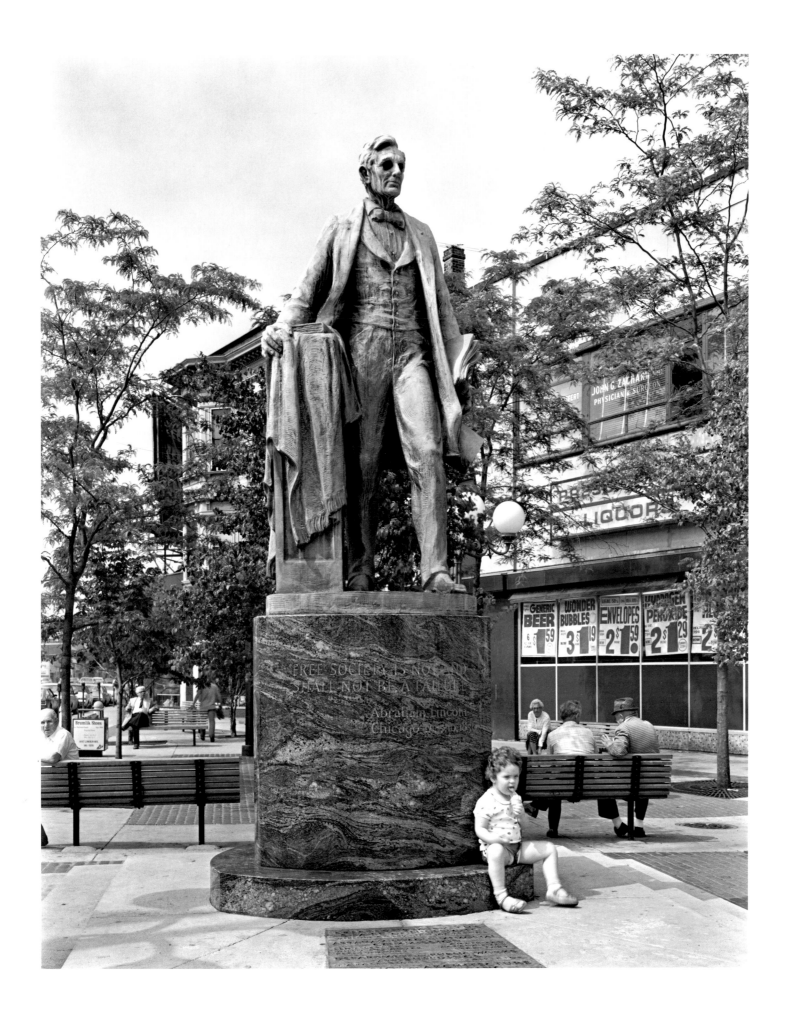

Carlinville, Illinois, 1983

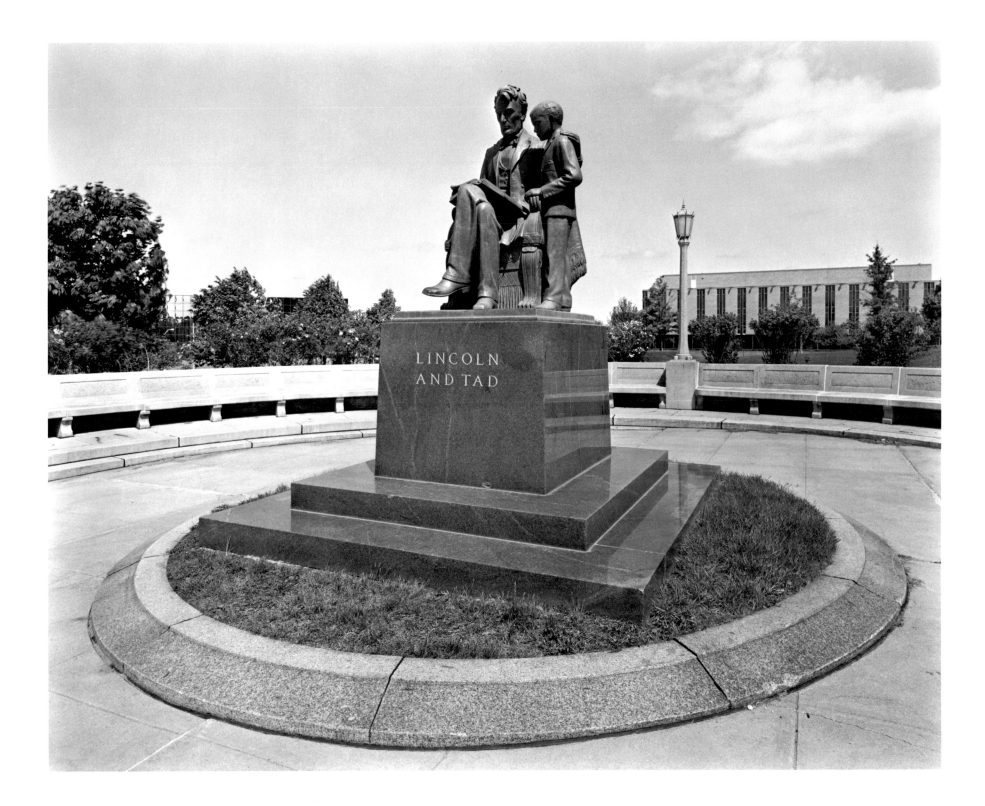

Des Moines, Iowa, 1983

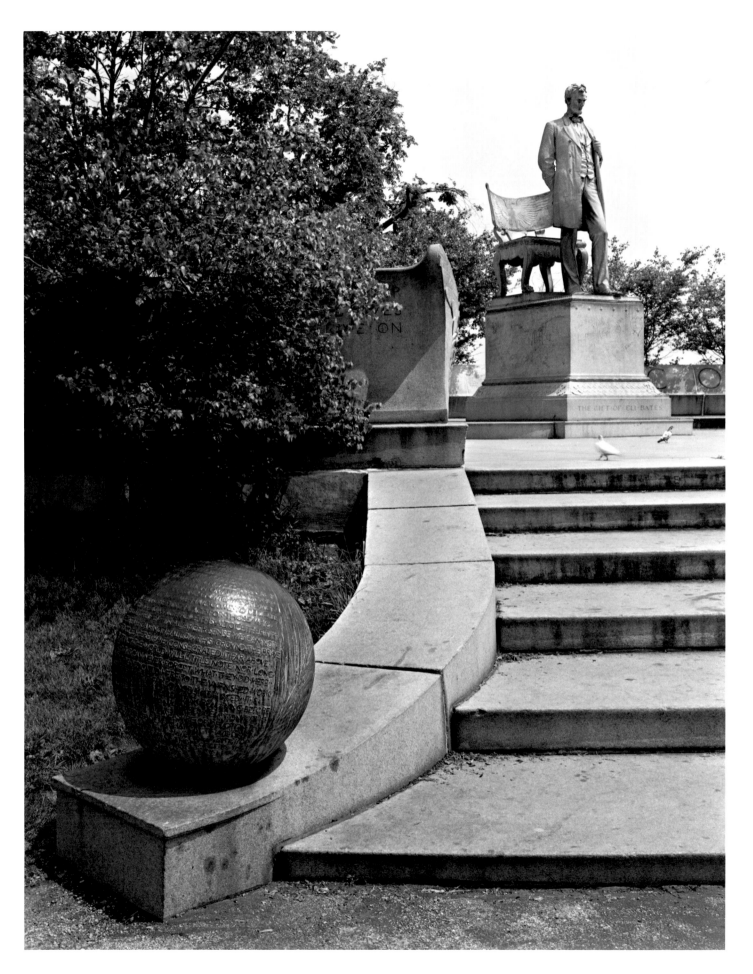

Chicago, Illinois, 1982

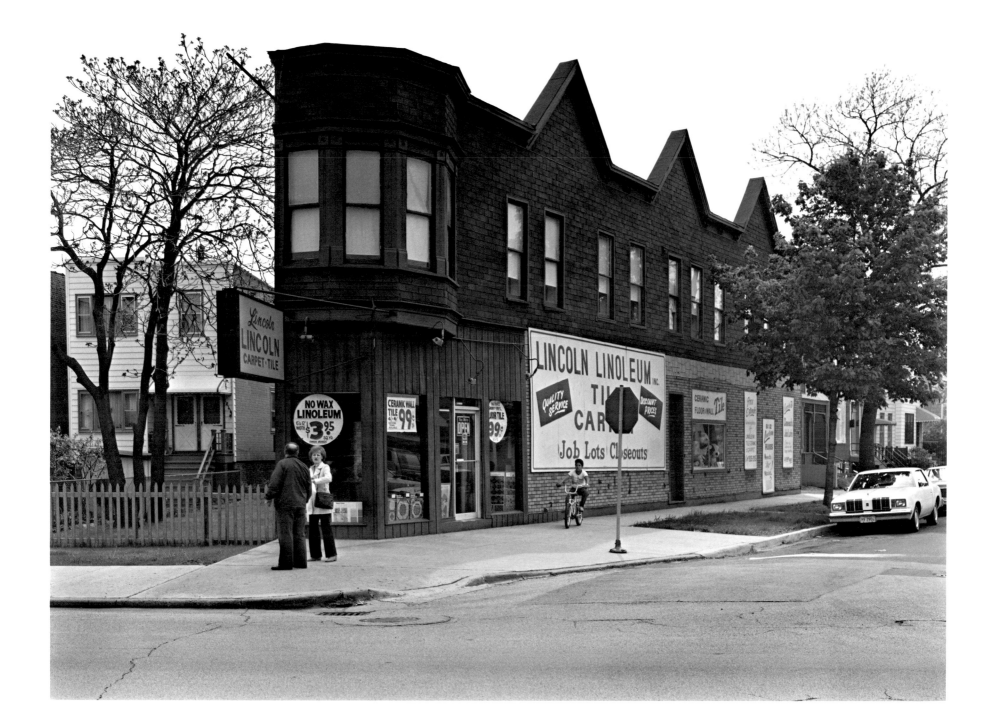

Chicago, Illinois, 1983

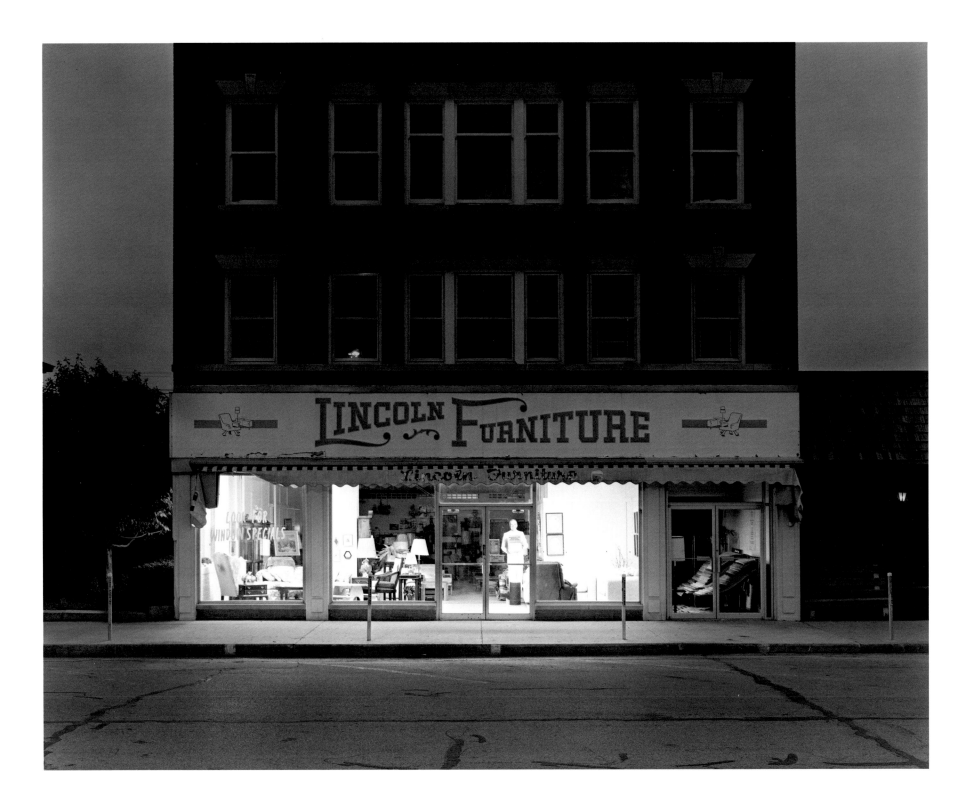

Lincoln, Illinois, 1982

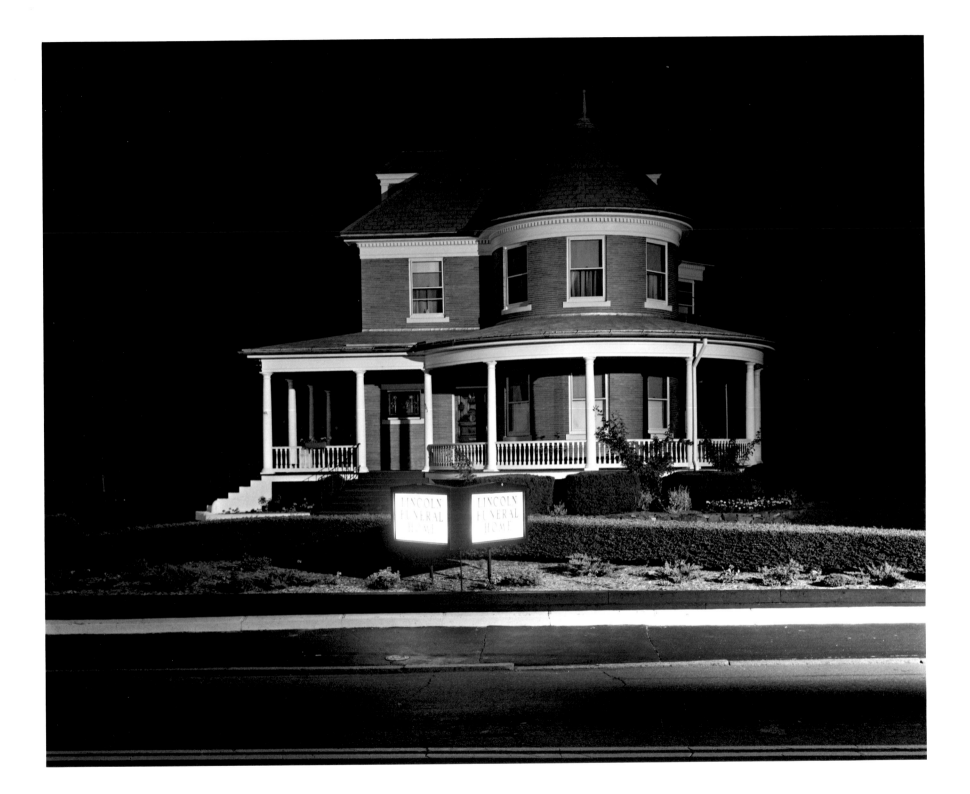

Lincoln, Rhode Island, 1982

Newark, New Jersey, 1981

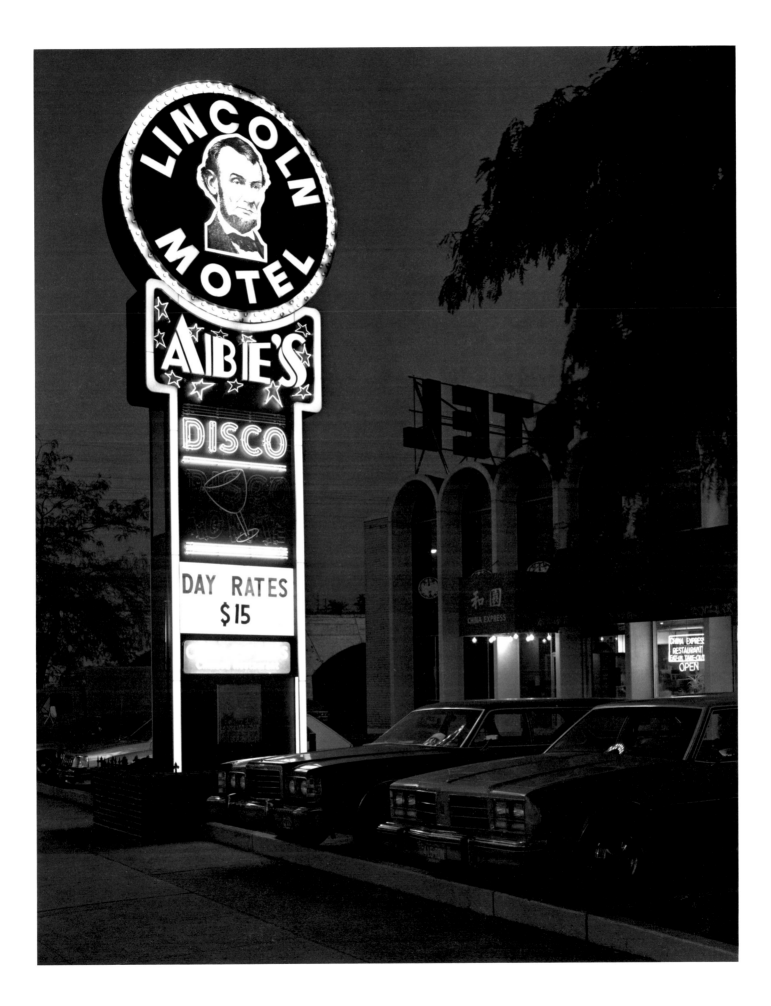

Charlestown, Illinois, 1983

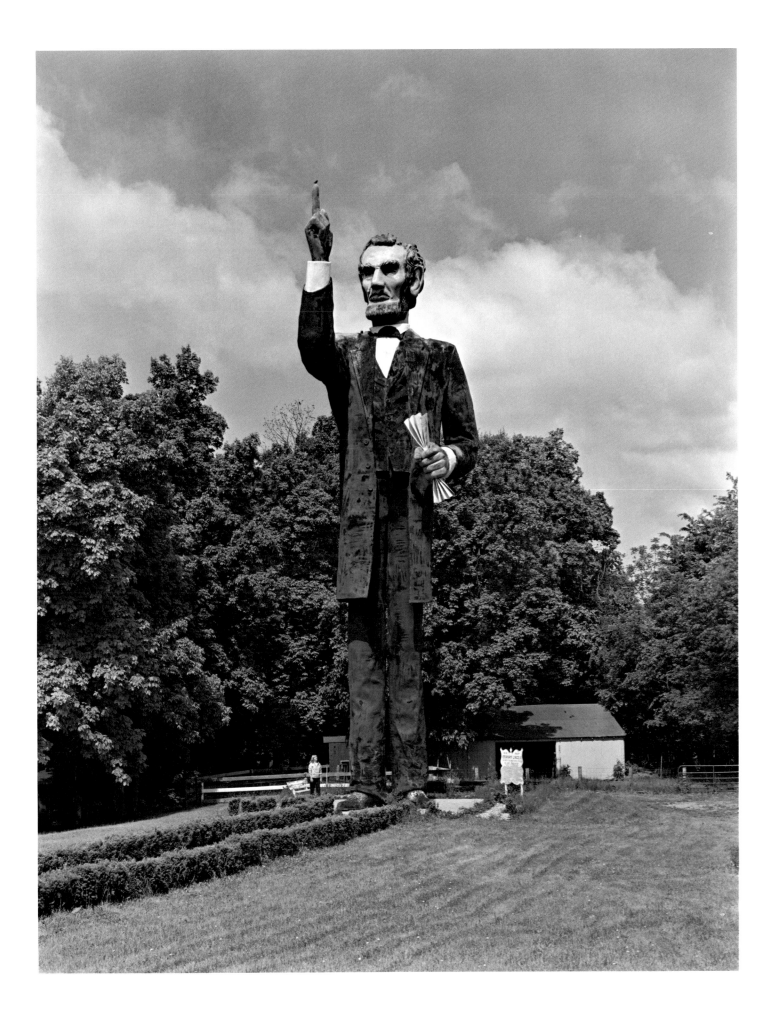

Council Bluffs, Iowa, 1983

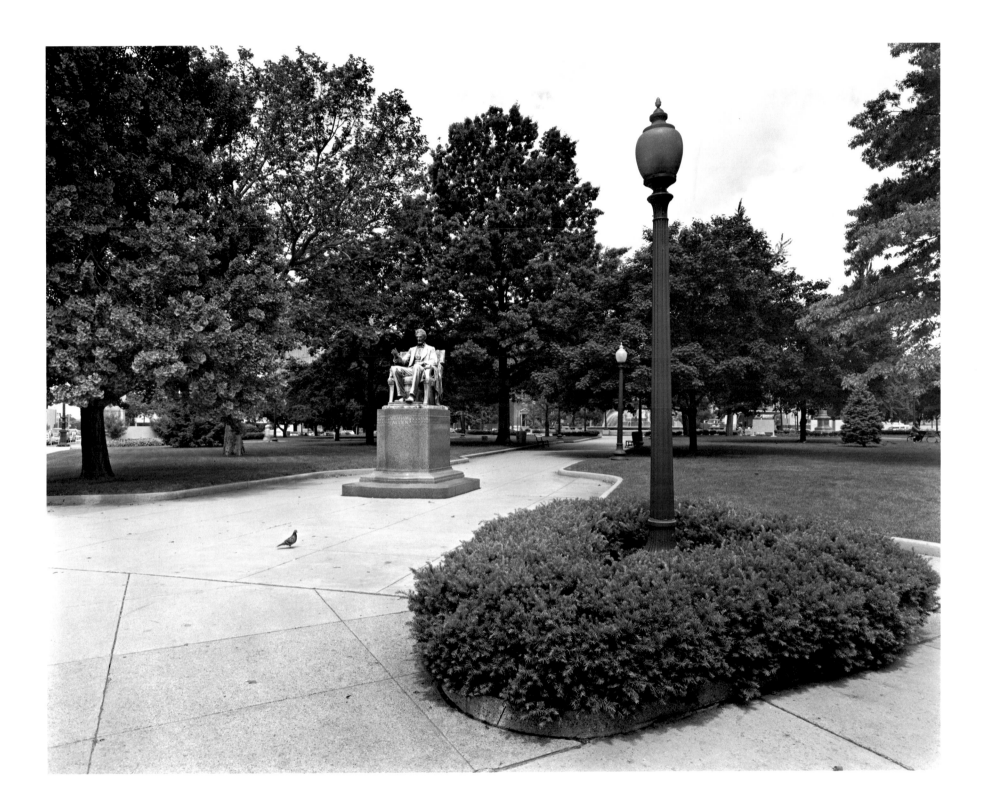

Indianapolis, Indiana, 1983

Springfield, Illinois, 1982

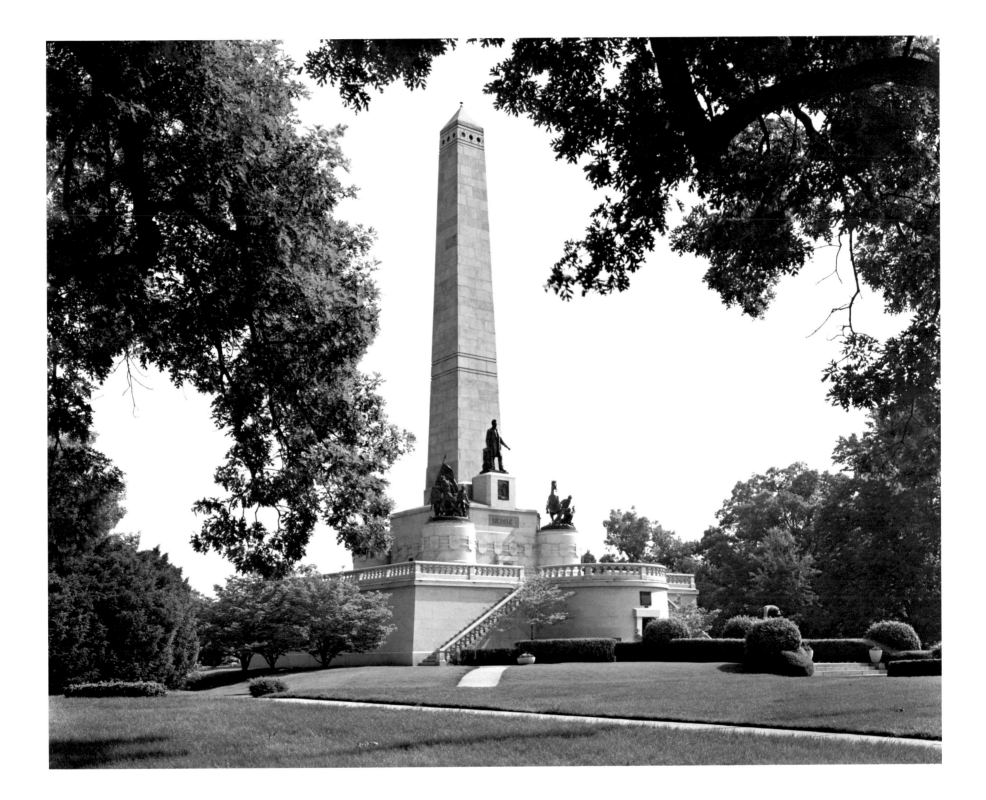

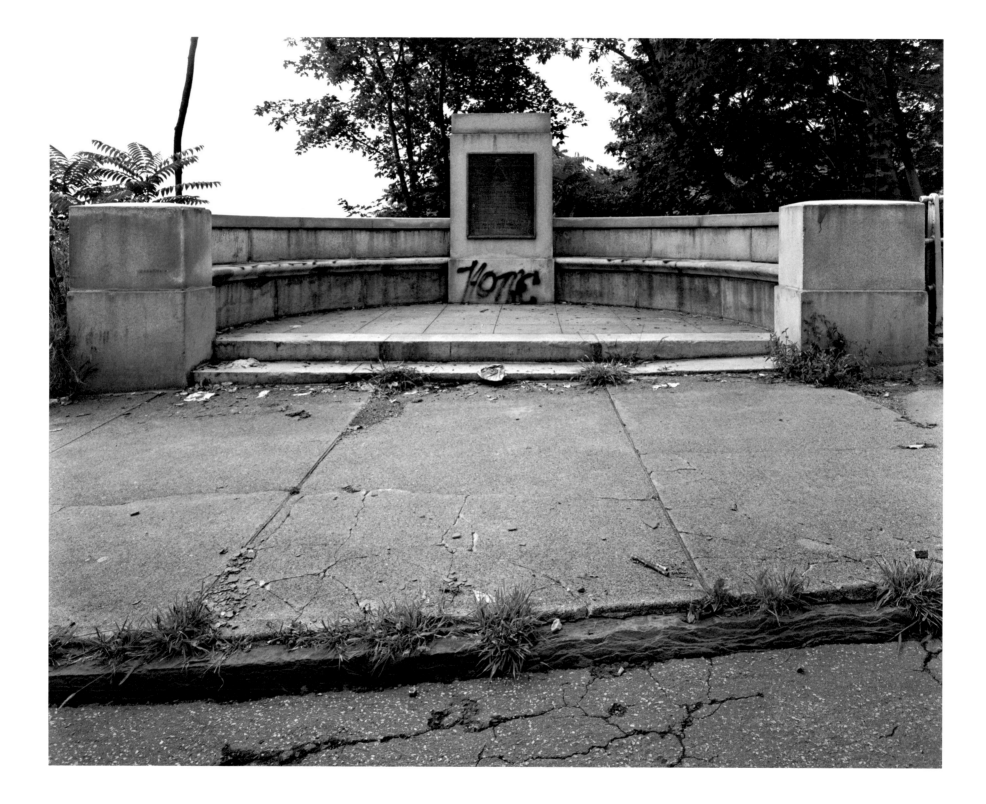

Peekskill, New York, 1982

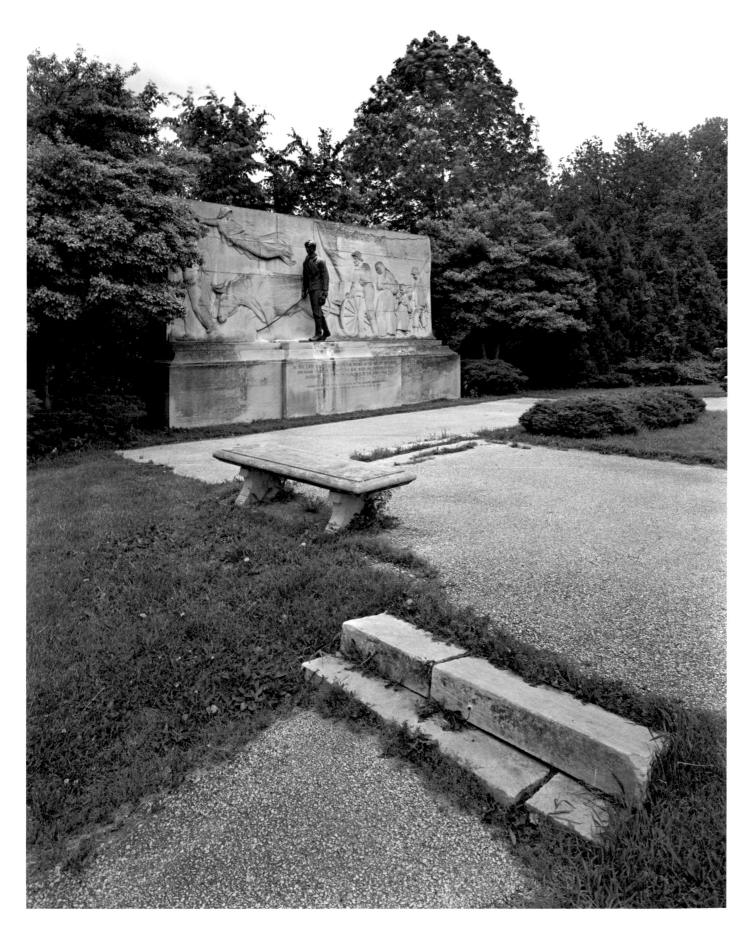

Lawrence County, Illinois, 1983

Wilkensburg, Pennsylvania, 1983

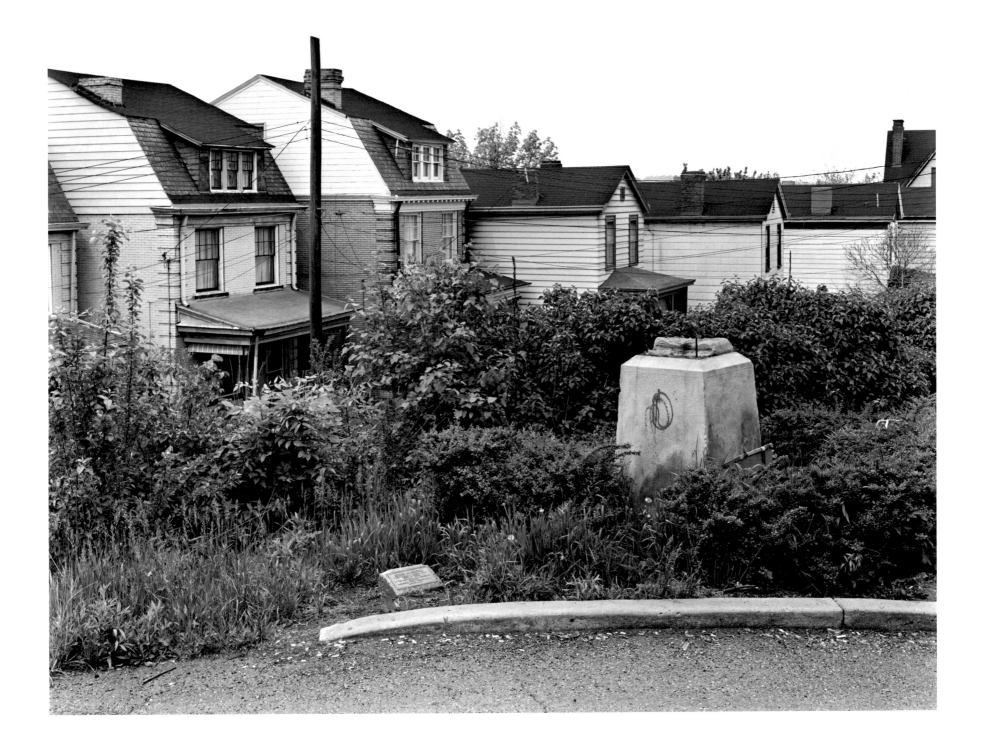

Washington, District of Columbia, 1983

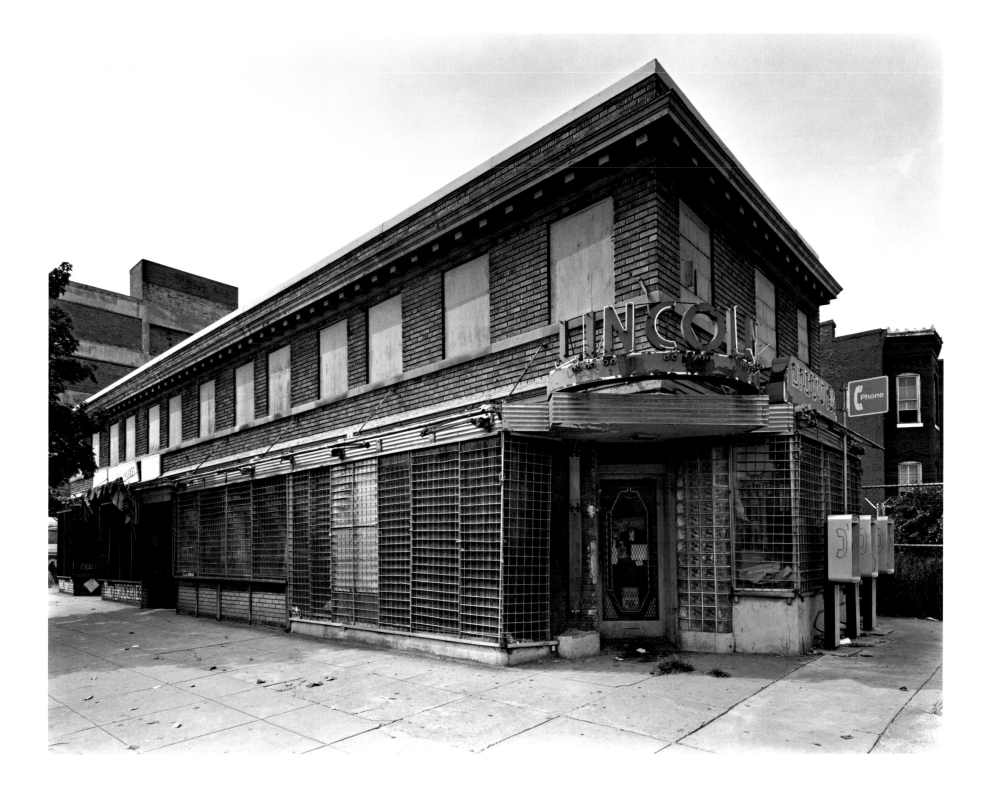

Prince Georges County, Maryland, 1983

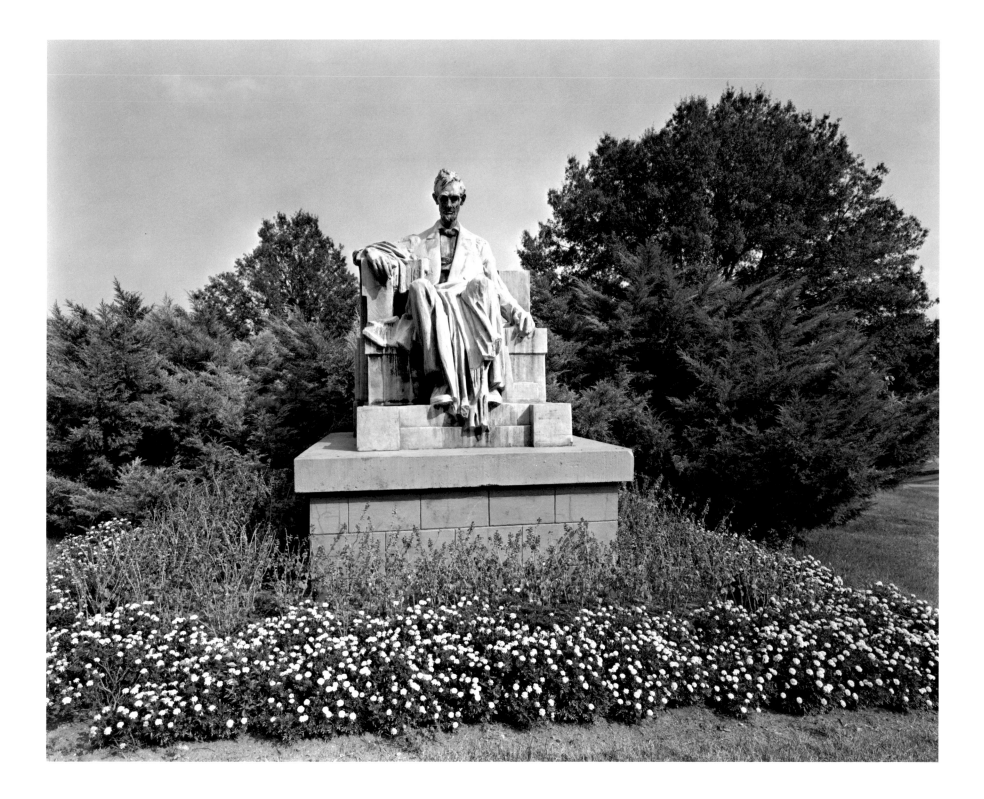

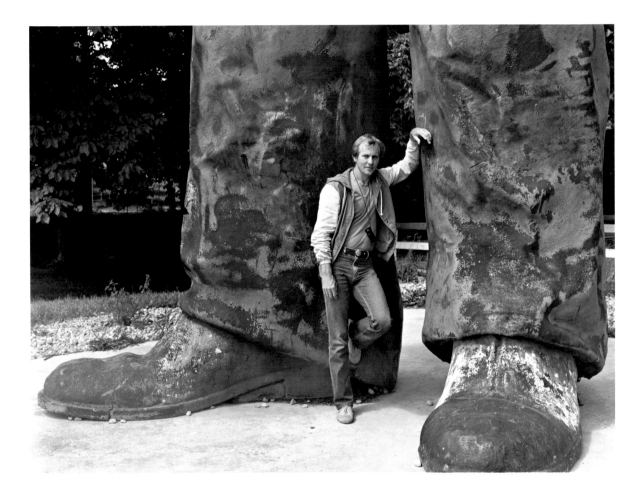

George Tice, Charlestown, Illinois, 1983 [Author Portrait]

LINCOLN
Type/Galliard
Composition/David E. Seham Associates
Printing/Meriden Gravure Company
Paper/Warren's Offset Enamel
Binding/Publishers Book Bindery
Design/George Tice and Barbara Maryanski